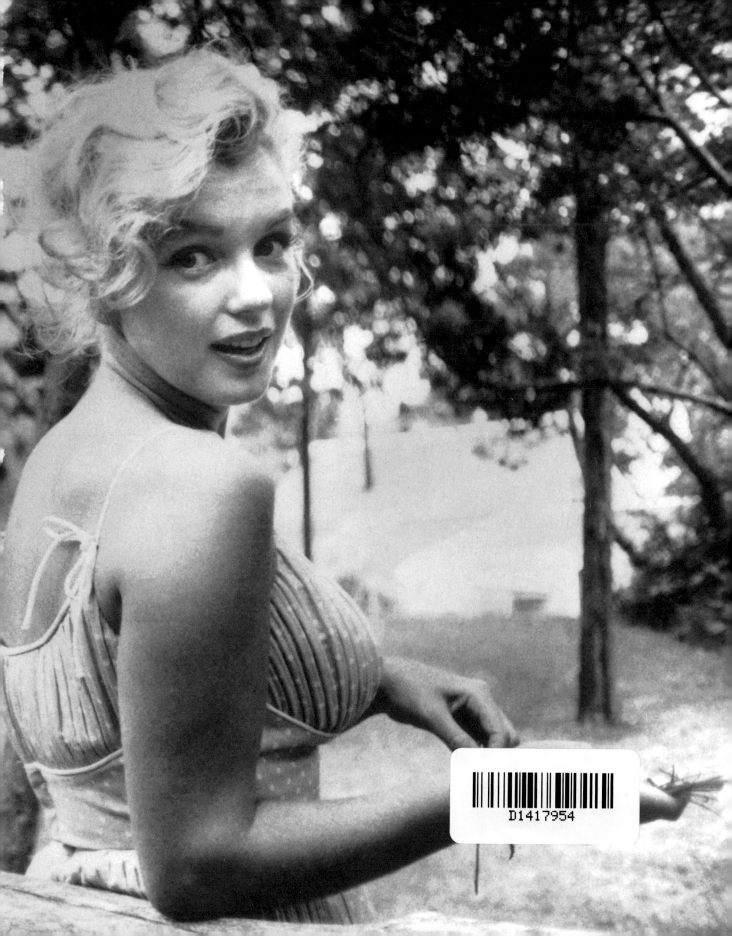

The Loves of Marilyn

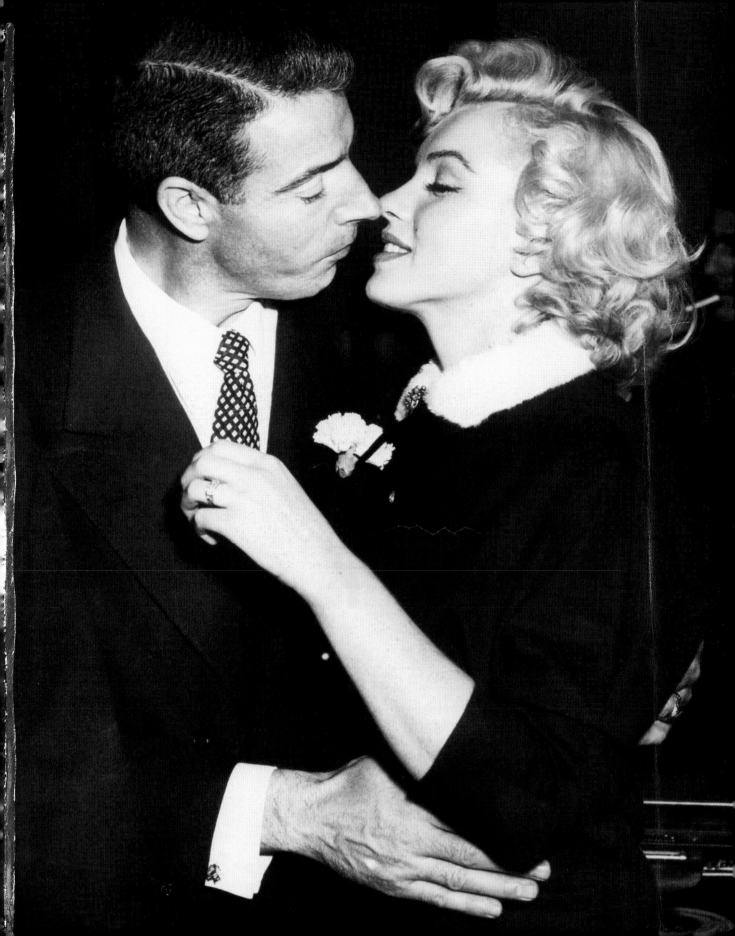

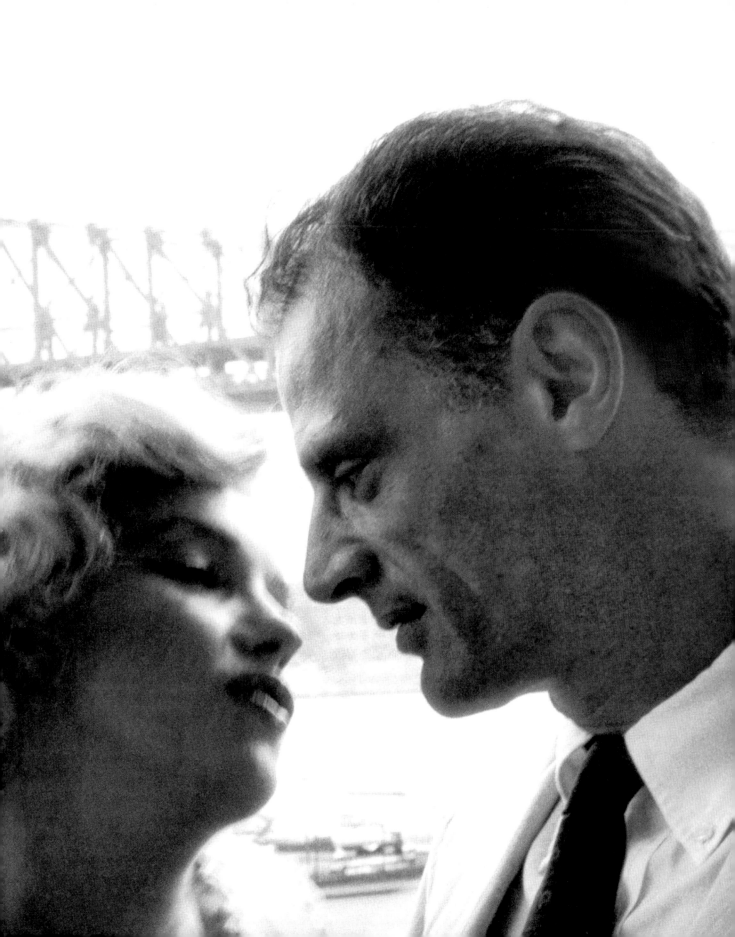

LIFE Books

Managing Editor Robert Sullivan
Director of Photography Barbara Baker Burrows
Creative Director Mimi Park
Deputy Picture Editor Christina Lieberman
Copy Chief Parlan McGaw
Copy Editors Don Armstrong, Barbara Gogan
Writer-Reporters Marilyn Fu, Amy Lennard Goehner,
Daniel S. Levy
Associate Picture Editor Sarah Cates
Special Contributor J.I. Baker
Photo Assistant Jehan Jillani
Consulting Picture Editors Mimi Murphy (Rome),
Tala Skari (Paris)

TIME Inc. Premedia: Richard K. Prue (Director), Brian Fellows
(Manager), Richard Shaffer (Production), Keith Aurelio,
Jen Brown, Charlotte Coco, Liz Grover, Kevin Hart,
Mert Kerimoglu, Rosalie Khan, Patricia Koh, Marco Lau,
Brian Mai, Po Fung Ng, Rudi Papiri, Robert Pizaro,
Barry Pribula, Clara Renauro, Vaune Trachtman

TIME HOME ENTERTAINMENT
Publisher Jim Childs
Vice President, Finance Vandana Patel
Executive Director, Marketing Services Carol Pittard
Executive Director, Business Development Suzanne Albert
Executive Director, Marketing Susan Hettleman
Publishing Director Megan Pearlman
Associate Director of Publicity Courtney Greenhalgh
Assistant General Counsel Simone Procas
Assistant Director, Special Sales Ilene Schreider
Senior Book Production Manager Susan Chodakiewicz
Senior Manager, Category Marketing Bryan Christian
Associate Prepress Manager Alex Voznesenskiy
Associate Project Manager Stephanie Braga

Editorial Director Stephen Koepp
Senior Editor Roe D'Angelo
Copy Chief Rina Bander
Design Manager Anne-Michelle Gallero
Editorial Operations Gina Scauzillo

Special thanks: Katherine Barnet, Brad Beatson,
Jeremy Biloon, Rose Cirrincione, Assu Etsubneh,
Mariana Evans, Christine Font, Hillary Hirsch, David Kahn,
Jean Kennedy, Amy Mangus, Kimberly Marshall,
Courtney Mifsud, Nina Mistry, Dave Rozzelle, Matthew Ryan,
Ricardo Santiago, Holly Smith, Adriana Tierno

ISBN 10: 1-61893-125-3
ISBN 13: 978-1-61893-125-2
Library of Congress Control Number: 2014942265

"LIFE" is a registered trademark of Time Inc.

We welcome your comments and suggestions about
LIFE Books. Please write to us at: LIFE Books
Attention: Book Editors
PO Box 11016, Des Moines, IA 50336-1016

If you would like to order any of our hardcover Collector's Edition
books, please call us at 800-327-6388
(Monday through Friday, 7 a.m.–8 p.m.,
or Saturday, 7 a.m.–6 p.m. Central Time).

Page 1: DiMaggio and Monroe kiss following their
marriage ceremony in a judge's chambers in San Francisco,
on January 14, 1954.
PHOTOGRAPH FROM BETTMANN/CORBIS

Pages 2–3: Monroe and Miller in New York City
on June 15, 1956, shortly before they wed.
PHOTOGRAPH BY SAM SHAW/REX USA

These pages: Monroe in Hollywood, in November 1961,
nine months before her death.
PHOTOGRAPH BY DOUGLAS KIRKLAND/CORBIS

Contents

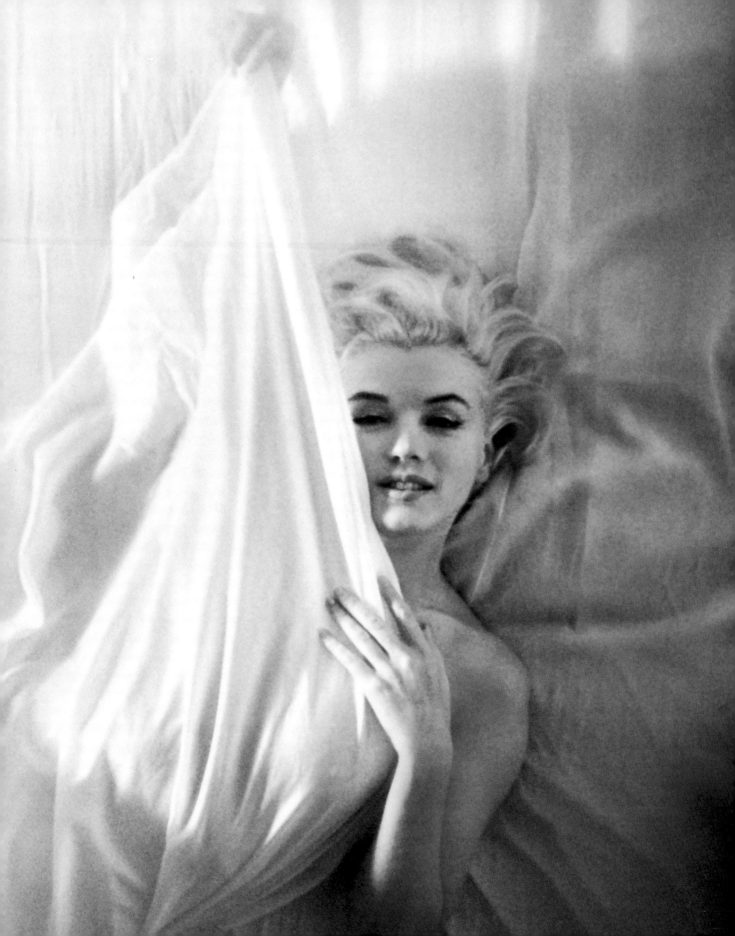

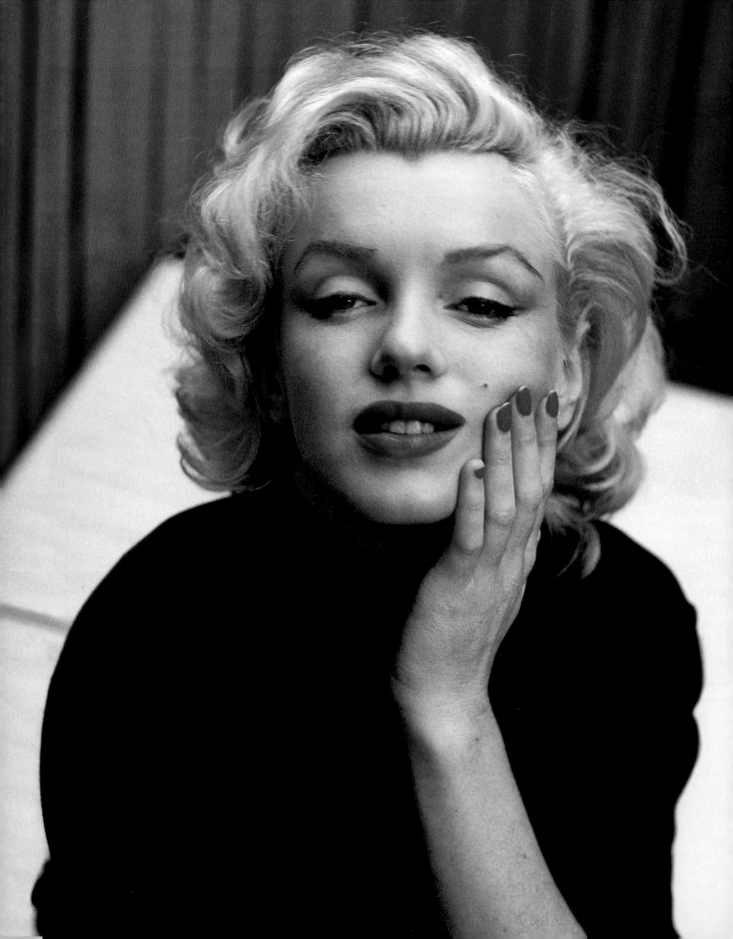

Introduction
Love, and a Lonely Girl

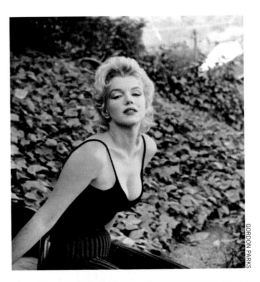

NORMA JEANE BAKER WAS TURNING 10 IN 1936. SHE WAS destined to be a lovely and precocious teenager in several ways. LIFE magazine was newly born in 1936. It would very quickly become an essential part of the American fabric, the preeminent weekly source of news and stories that could be told in words and pictures. Norma Jeane Baker, as she segued into Marilyn Monroe, was made for pictures. And she certainly had a story worth telling. LIFE was her accomplice back in the day, and has been ever since. We grew up together.

We say *accomplice,* and that's a purposeful word. For one thing, Marilyn, ascending to stardom in a business built on the visual image, came to know many of our photographers and collaborated with them on shoots you will see in these pages. She opened her doors to LIFE and never shied from our lenses when out on the town with this husband or that one, this lover or the next.

But it was what has often been called a simpler or more innocent age. Just as sportswriters never revealed the extent of Babe Ruth's after-hours "socializing" a generation earlier, LIFE, while showing much, didn't delve into the implications of the photographic evidence as Marilyn made her progress through what was, we now know, a very complicated love life.

Today, of course, the complete story can and has been told. In our book, J.I. Baker, author of the novel *The Empty Glass,* which deals vividly with Monroe's death, writes of the great passions and lighter dalliances that filled the legendary actress's too short life. He knows what remains a rumor and what is a fact, and he helps us understand not only Marilyn's desires but her regular episodes of heartbreak.

In LIFE's last interview with Monroe, conducted and published very shortly before she died in 1962, Richard Meryman did probe deeper than we had previously, and revealed a woman looking back at an extraordinary road traveled—a woman wondering at it all. And then, suddenly, she was gone. Meryman was moved to write a concluding piece for the magazine entitled "A Last Talk with a Lonely Girl." In these pages, J.I. Baker and many of Hollywood's best-ever photographers take us down that road once more and paint a complete portrait of filmdom's most famous star.

It never was, of course, a simpler or more innocent age. The loves of Marilyn were rife with controversies and complexities, tempestuous times and moments of true romance. Taken together, they are a tale of Tinseltown unlike any other.

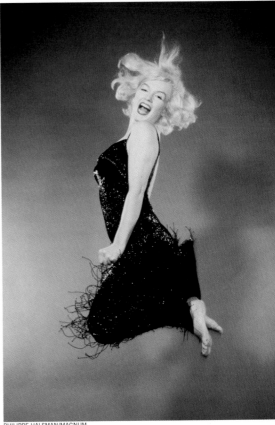

Marilyn was a favorite of LIFE's, and LIFE's photographers were among Marilyn's favorites. On these pages are three of our favorite portraits of her, made by Alfred Eisenstaedt in 1953 (opposite), by Gordon Parks in 1956 (top) and by Philippe Halsman in 1959. Halsman, who shot more covers for LIFE— 101—than anyone else, said, "Of the beautiful women I have photographed, I recall Marilyn Monroe most vividly. Her great talent was an ability to convey her 'availability.' I remember there were three men in the room . . . Each of us had the thought that if the others would only leave the room that something would happen between Marilyn and himself." To get the cover photo seen here, Halsman needed her to jump 200 times. Before she left, she told him to call if another take was necessary—"even if it is four in the morning."

PHILIPPE HALSMAN/MAGNUM

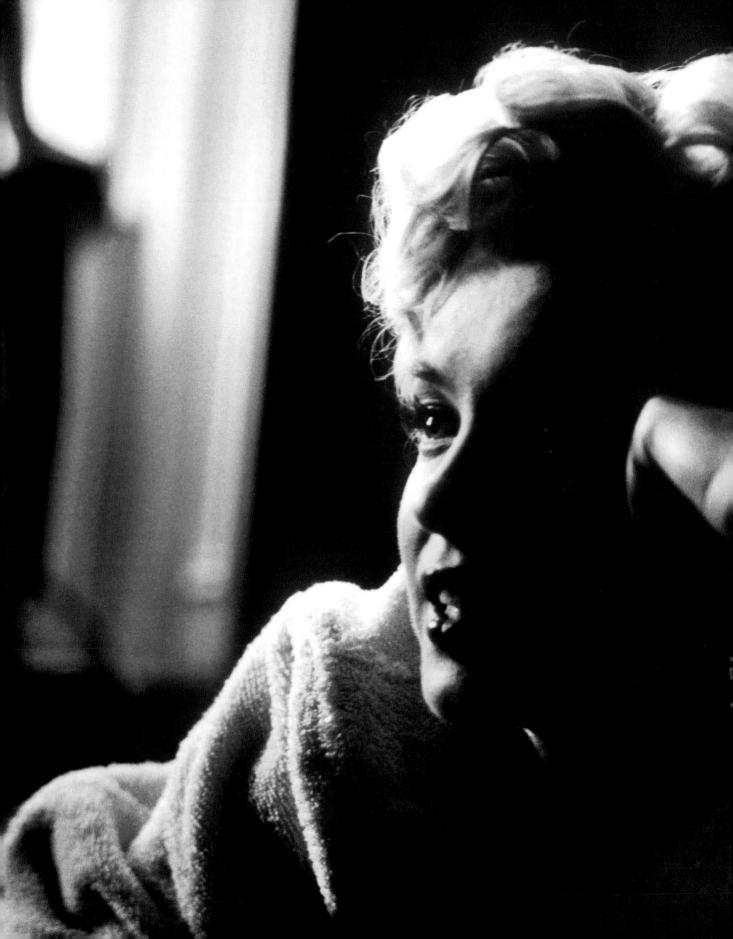

The Loves *of* Marilyn
By J.I. Baker

The Heart of the Matter

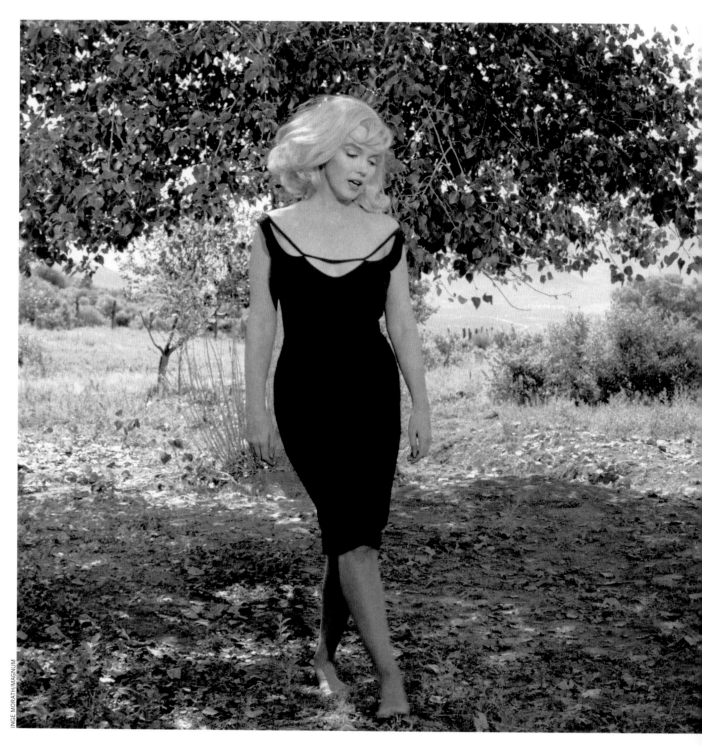

IT WAS A LIFE SO GLAMOROUS, SO ROMANTIC AND
yet so tragically ended. In the early morning hours of August 5,
1962, a call came into the West Los Angeles Police Department
saying that Marilyn Monroe had overdosed—"a suicide," her doc-
tor, Hyman Engelberg, said. The watch commander on duty, Jack
Clemmons, was summoned to the 36-year-old star's hacienda at
12305 Fifth Helena Drive, Brentwood, where Monroe, the most
famous woman in the world, lay naked and dead on a disheveled
bed. On the scene were Engelberg; Monroe's psychiatrist, Ralph
Greenson; and her housekeeper, Eunice Murray.

The Los Angeles County coroner's official ruling, which few
accepted at the time, was suicide due to "acute barbiturate poi-
soning." Suspicion immediately mounted surrounding a num-
ber of strange events, which only served to make everything
even more tawdry and sad: Engelberg and Greenson had waited
four hours before calling the cops, citing their need to first alert
the publicity office at 20th Century-Fox, where the star had
been making a film; the autopsy was hopelessly botched; tissue
samples that would have conclusively indicated how drugs had
entered Monroe's body mysteriously disappeared. The rumors
hit the streets as quickly as the tabloids did: Both Attorney
General Bobby Kennedy and his brother Jack—then President
of the United States—were entangled in a dangerous *folie à trois*
with the needy, increasingly unstable actress. They were only two
in a long line of lovers that included Frank Sinatra and Marlon
Brando, not to mention ex-husbands Joe DiMaggio and Arthur
Miller. "She played pathetic dramas of seduction and abandon-
ment with high-profile heroes," wrote Evan Thomas, author of
2000's *Robert Kennedy: His Life.*

She did. We all know that. We've known it for half a century
now, and those who cared to know it knew it longer ago than that.

But Monroe's pursuit of fame—and of love—had begun, as
such pursuits often do, humbly—even (and this is not a word often
applied to Marilyn Monroe, though it might have been, once,
to Norma Jeane Baker) modestly. As we will now see in parad-
ing through the fabled and sometimes almost anonymous loves
of Marilyn, her first marriage was to a seaman in the Merchant
Marine—about as far from the Hollywood heights of celebrity
matrimony (and affairs) as this child bride would thereafter
arrive. If Norma Jeane and Jimmie had been forever, she might
well have led a happier life. But she never would have become
Marilyn Monroe.

*In 1960, Monroe is in Reno, Nevada, to make what will be her
last movie. The film is* **The Misfits,** *directed by John Huston from
a screenplay by Arthur Miller, from whom Monroe will soon be
divorced. In a 1981 interview Huston said that in observing Monroe
on the set, he grew "absolutely certain that Marilyn was doomed.
There was evidence right before me every day. She was incapable of
rescuing herself or of being rescued by anyone else."*

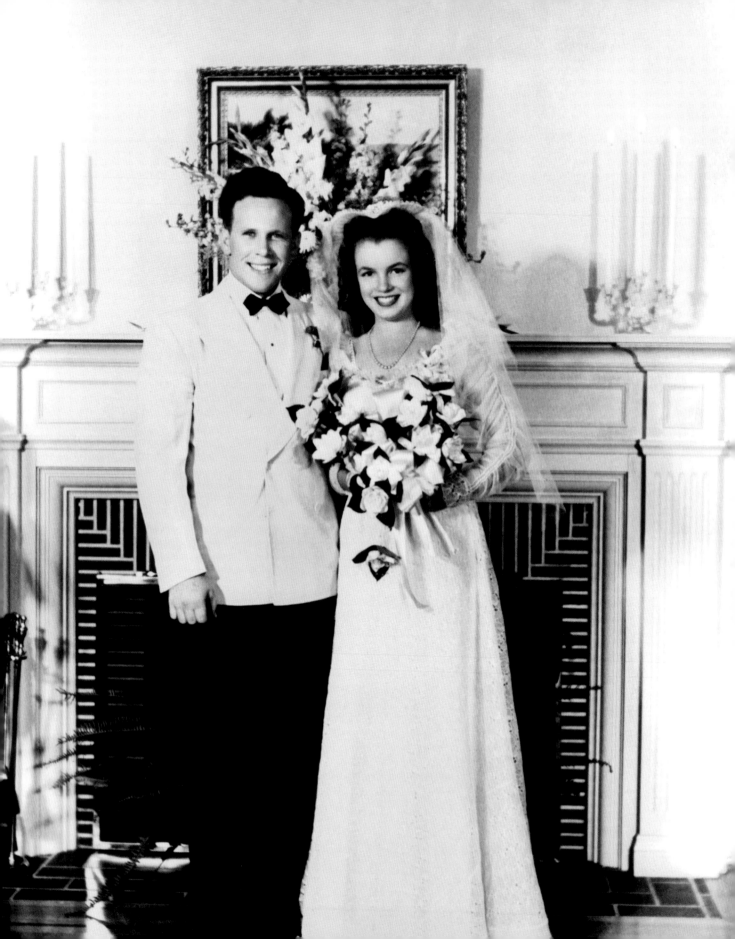

James Dougherty

"THE PURE PRODUCTS OF AMERICA GO CRAZY," THE POET William Carlos Williams once wrote. In the case of Monroe, this was literally true. Mental illness ran in her blood. Her maternal grandmother was schizophrenic, and her mother, Gladys, inherited the disorder, which would also come to haunt Monroe—even as she seemed to overcome a childhood that was truly Dickensian in its neglect and brutality.

It's hardly a stretch to suggest that the actress spent much of her life trying to compensate for the love that little Norma Jeane had not been shown. She never knew her father; she didn't even know for certain who he was. Some believe he was Stanley Gifford, a salesman for Consolidated Film Laboratories; there exists a photo of him in which you can indeed see a resemblance to the actress. Stanley also resembled Clark Gable, which resonated with the little girl who took refuge in the silver screen. "Some of my foster families used to send me to the movies to get me out of the house," Monroe said, "and there I'd sit all day and way into the night—up in front, there with the screen so big, a little kid all alone." Very early on, she decided that Gable was her father.

In 1954, Monroe gave a series of interviews to the writer Ben Hecht, later published as *My Story*. Though the star would thereafter disavow the project, there is every reason to believe the interviews were as legitimate—as honest—as any of the many others she gave. In them, she told Hecht that she had lost her virginity at age eight to a boy she called George. "We used to hide in the grass together," she said. "I knew it was wrong . . . but I didn't know *what* was wrong. At night I lay awake and tried to figure out what sex was and what love was."

Sex—and sexual abuse—dominated her thoughts. She claimed that, also at age eight, she had been molested by one of her mother's borders, a British actor named Murray Kinnell. (She called him Kimmell.) And she told the journalist Lloyd Shearer that she had been "assaulted by one of her guardians, raped by a policeman, and attacked by a sailor." He wrote, "She seemed . . . to live in a fantasy world, to be entangled in the process of invention, and to be completely absorbed in her own sexuality."

From random anecdotes to the manufacture of her Hollywood persona, Monroe, quite simply, did make things up. She herself was often uncertain where the lies ended and reality began. When dealing with such a person, it is difficult to establish the facts, no matter how objective or diligent you try to be. The alleged molestations are mentioned here because, even if they weren't objectively true, they were most likely *subjectively* true for her. She was a victim, in her own eyes. And she wanted to find someone she could trust, according to her testimony.

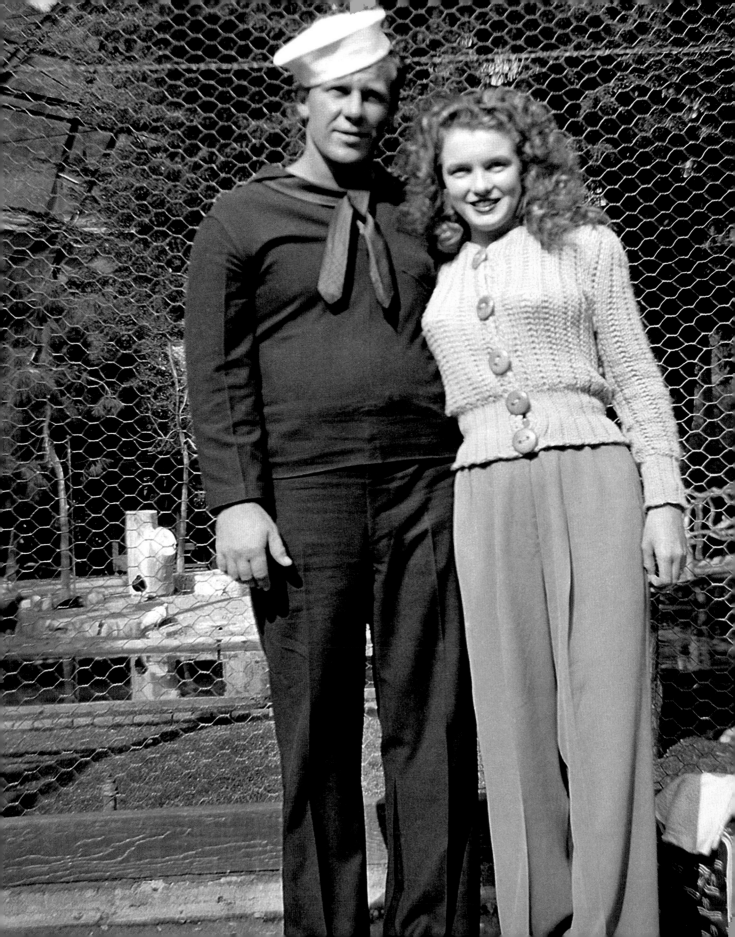

Because of her mother's instability, young Norma Jeane was shuttled between boarding houses, foster families, the houses of friends and finally the Los Angeles Orphans' Home Society, where she was labeled child number 3,463. As always, she dealt with unpleasant reality by retreating into fantasy. "I daydreamed chiefly about beauty," she said. "I dreamed of myself becoming so beautiful that people would turn to look at me when I passed . . . I dreamed of myself walking proudly in beautiful clothes and being admired by everyone and overhearing words of praise."

The daydreams would soon come true. The rapidly maturing Norma Jeane discovered a previously unknown source of power when, one day, she wore a sweater borrowed from a smaller girl to her seventh-grade class at Emerson Junior High. It stunningly emphasized the 12-year-old's bust. "I arrived at school just as the math class was starting," Monroe said. "Everybody stared at me as if I had suddenly grown two heads, which in a way I had. At recess a half dozen boys crowded around me. I didn't think of my body as having anything to do with sex. It was more like a friend who had mysteriously appeared in my life, a sort of magic friend." Norma Jeane's blossoming body led, in 1939, to dates with her first sweetheart, a boy named Chuckie Moran. He took her dancing, though he clearly wanted more than fancy footwork. "Poor Chuckie," she said later. "All he got was tired feet."

In the fall of 1940, 19-year-old James Dougherty was asked to drive Norma Jeane and another girl, Bebe—both of whom were living at the home of Grace and Doc Goddard—back from Van Nuys High School. He agreed, thereby beginning a casual relationship that would culminate in marriage. The United States entered World War II in 1941, and the following year, the Goddards decided to move east. Rather than put Norma Jeane into another foster home, or—worse—the orphanage again, they turned to Dougherty.

The young man was hardly a catch. He had only a high-school diploma, having skipped college to work—first in a funeral home, later at Lockheed aircraft. But he was decent, good-looking and available. He and Norma Jeane were encouraged to get married. Though Dougherty claimed he'd never considered marriage—Norma Jeane was just a girl, and he liked adult women—it didn't take him long to embrace the idea. There was just one hitch: They had to wait for her to turn 16.

On June 19, 1942, the couple tied the knot in Brentwood.

There is an almost comic discrepancy between Monroe's and Dougherty's versions of the four years they spent together. "I loved how she needed me," he wrote in his 2000 memoir, *To Norma Jeane with Love, Jimmie.* "My feelings for [her] were very deep and amazingly strong." Marilyn, for her part, said: "It was like being retired to a zoo."

*T*heirs would not be an endless honeymoon—that would be an impossibility in the life of Norma Jeane Baker—but it was something of an extended one. The formal version took place at a lake in California's Ventura County, then the Doughertys moved into a studio apartment with a pull-down Murphy bed in Sherman Oaks, outside L.A. In 1943, Jim joined the Merchant Marine (opposite, in uniform) and was initially assigned to teach sea safety on Catalina Island, off the Southern California coast, where the young couple moved into an apartment. "She was just a housewife," Dougherty said to UPI in 1990. "We would go down to the beach on weekends, and have luaus on Saturday night. She loved it over there. It was like being on a honeymoon for a year." In 2004, he told **The Boston Globe,** *"We loved each other madly. I felt like the luckiest guy in the world."*

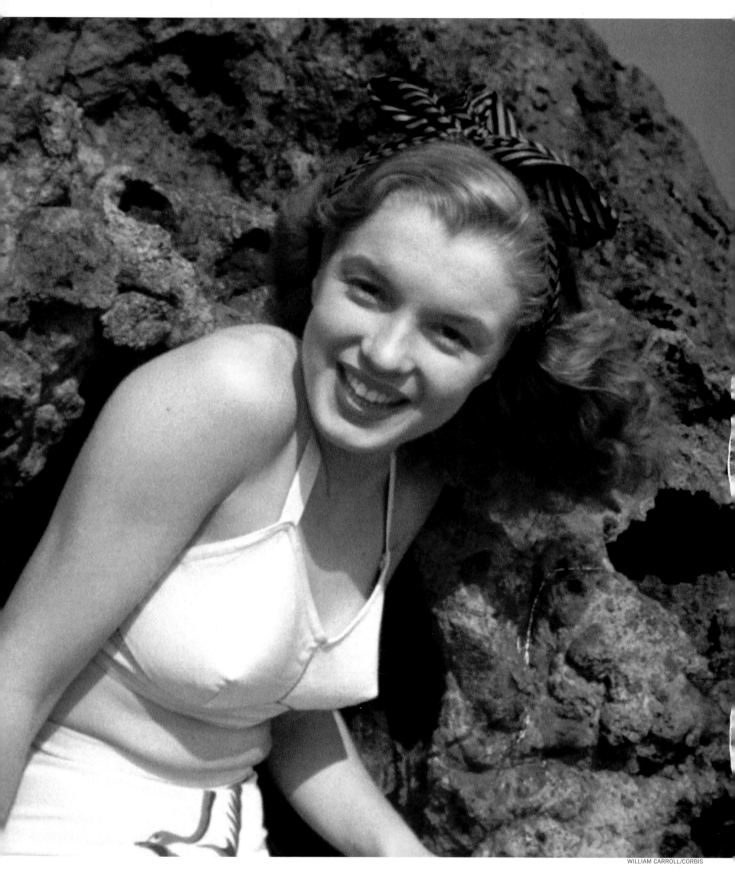

When Jim Dougherty received an overseas assignment in the Merchant Marine, Norma Jeane moved back to Van Nuys. She landed a job at the Radioplane company, where she initially packed and inspected the parachutes that were attached to miniature, remote-controlled target planes. After a photographer took pictures of the young Mrs. Dougherty, she became a sought-after model in the Los Angeles area, and Hollywood beckoned. Her marriage to Dougherty was, of necessity, officially over in September 1946 when she filed for a quickie divorce in Vegas. "I was on a ship in the Yangtze River getting ready to go into Shanghai when I was served with divorce papers," Dougherty told the Associated Press in 2002. He protested with his wife, but as he explained to UPI in 1984, "She wanted to sign a contract with [20th Century] Fox and it said she couldn't be married—they didn't want a pregnant starlet. When I went back to see her, I tried to talk her out of it. She wanted me to be there—she just wanted us to keep on and not be married for the contract. I couldn't do that." Dougherty remarried, and had "three beautiful children" with his second wife. He never saw any Marilyn Monroe movies in the theater because his wife didn't want the actress's name mentioned in their home. "I destroyed all my letters from Norma Jeane," he said, "hundreds of them. I don't need them for a memory, but I probably could have built a house for what they are worth."

Their perspective on their shared sex life differed wildly too. Dougherty insists that—contrary to Monroe's later claims—Norma Jeane was a virgin on their wedding night, adding that she soon learned to love lovemaking. "We both had trim bodies and the sight of hers and mine nude excited both of us," he said. "Getting undressed for bed was almost unfailingly erotic and almost before the light was out we were locked together. If I took a shower and she opened the door it was the same thing all over again—instant sex." For her part, Monroe said, "The first effect marriage had on me was to increase my lack of interest in sex." It is hoped, for the woman's sake, that some of Dougherty's ungallant reminiscences were true; it is nice to imagine such passion in her life. Several of Marilyn Monroe's future lovers, when they spoke, were hardly effusive about her performance. That's the irony, certainly: Eroticism would fuel her public persona, but she herself was often left out of the fun.

One year after the marriage, Dougherty became a sailor, stationed not abroad—as Norma Jeane had feared—but on Catalina Island, off the California coast. Later, after he was shipped overseas, his bride went to live with his mother, making extra money working in the Radioplane munitions factory at the Glendale Metropolitan Airport. She wore her drab work overalls suggestively. "Putting a girl in overalls is like having her work in tights, particularly if a girl knows how to wear them," she said. "The men buzzed around me just as the high school boys had done."

One of them buzzed onto the scene from outside the factory. His name was Corporal David Conover. In fall 1944, he was sent by a Lieutenant Ronald Reagan—yes, *that* Ronald Reagan—to take photographs of Radioplane's female workers for *Yank* magazine. The pictures were intended to raise morale. Conover immediately saw that Norma Jeane possessed a face and body that were wasted among the parachutes and fuselages. Calling her a "hummmm-dinger," he offered her money to work as a model and photographed her in the Mojave Desert in 1945. Later, he claimed—as did others—to have been intimate with her. There's no evidence of this, but it's clear that his professional attentions were the beginning of her career.

Before Conover shipped out to the Philippines, he told Norma Jeane to take his photos to Miss Emmeline Snively, founder of Blue Book, a modeling agency located in the now long-gone Ambassador Hotel (where, by the way, Bobby Kennedy would be assassinated after the 1968 California primary). Snively liked what she saw and began sending her eager recruit on a series of assignments. One of the first was at the Garden of Allah, the legendary hotel on the eastern edge of the Sunset Strip. It was there, in November 1945, that Norma Jeane met a photographer named Andre de Dienes.

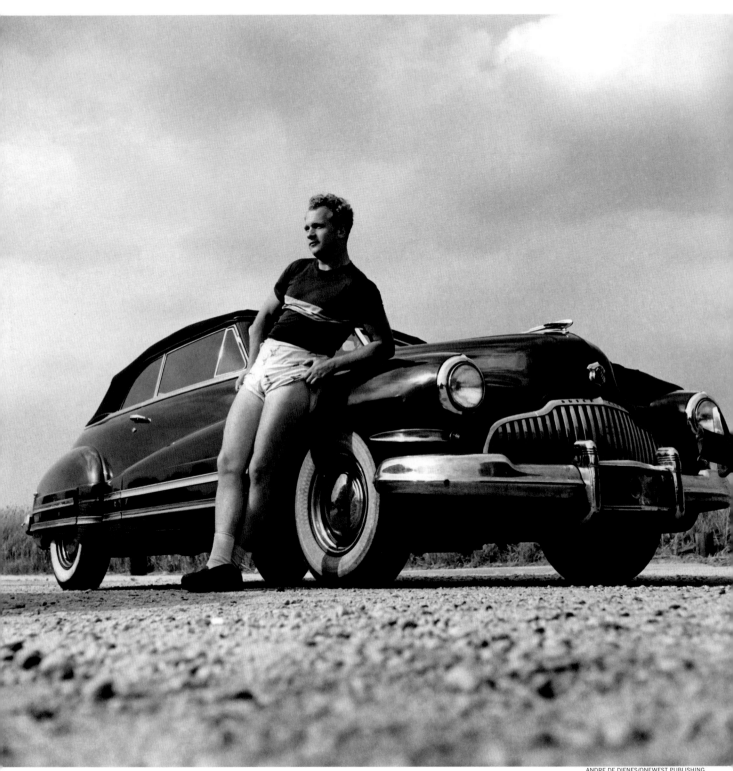

Andre de Dienes

"THERE CAME THIS LOVELY LITTLE GIRL IN A PINK SWEATER and checkered slacks," Andre de Dienes told the *Los Angeles Times* days after the star's death. He hired her on the spot, he remembered, taking her on a monthlong trip up the West Coast, photographing her in the ocean, the snow and the mountains. (Her pay: a flat rate of $200 for the several sessions.) "I loved her," he said. "I was going to marry her. Was she in love with me? Of course she was in love with me. But . . . a girl who wants to be a model is out as a wife. What does a woman need, basically? Home, cooking, scrubbing, children, a husband who loves her."

As sexist as de Dienes's view is, and as absurd as his itemization seems when even mentioned in the context of the woman we now know as Marilyn Monroe, there were times when young Marilyn believed such things—or said she wanted to believe them. De Dienes recognized that she would never embrace domesticity with him—or, for that matter, with Dougherty. When he asked Norma Jeane if she really loved her husband, she said no. (Near the end of her life, she confessed to a reporter that she "gave in" to other men while Dougherty was away—most often out of sheer loneliness.)

"I want to love and be loved more than anything else in world," Monroe claimed. But was this true? There is no question that her efforts at loyalty, devotion and affection often were derailed by her ambition—her unquenchable ambition. She was quickly learning that her beauty and charisma could affect more than schoolboys and the men at Radioplane; and before long she set her sights on becoming an actress. It was quickly clear that her marriage was a problem: The all-powerful Hollywood studios didn't want to invest money and time in starlets who might become pregnant. The bottom line: If she really wanted a screen career, she would need to dump Dougherty. She did so with chilling and impersonal efficiency. Her husband was in China in May 1946 when he received word—via a lawyer's letter, no less—that the girl who'd seemed to need him so desperately had filed for a Las Vegas divorce. Though he tried to be philosophical at the time, he later admitted the obvious: "Norma Jeane really did hurt me." He added a thought others have echoed, though seldom so eloquently: "She became Marilyn completely and lost Norma Jeane to the ages."

The woman had perceived the door to her future and thought she knew who had the keys: older, powerful men. ("I have always been attracted to older men, because the younger men don't have any brains," she once said, and in this next period she acted on that notion.) Free of her husband, she dated the likes of photographer Bill Burnside and journalist James Bacon. "She was promiscuous," said Bacon. "She admitted it helped." Indeed, the writer Anthony Summers, author of *Goddess,* the groundbreaking 1985 Monroe biography, claimed the actress may have been a call girl. Her acting teacher Lee Strasberg seemed to concur, but more delicately: "She was the one summoned if anyone needed a beautiful girl for a convention."

Sad stuff, certainly. But Marilyn was still young, and young, attractive people are often drawn to their counterparts in the opposite sex. And for the briefest moment, Marilyn paused in her ladder climbing and bonded with a surfer dude her own age. We'll meet him a few pages on, in our next chapter.

No one—not even the most salacious biographer—has said Jimmie Dougherty treated his wife anything but well, and no one has said Dougherty was the kind of hotshot boyfriend Marilyn Monroe would lean toward from here on in. With Andre de Dienes, the story changes, as do the boyfriends, husbands and lovers. He was born in Transylvania—don't read too much into that (or go ahead, if it entertains you)—and his mother committed suicide when he was a boy. At 15, de Dienes went vagabonding in Europe, arriving in Paris at age 20 to study art. He started taking photographs professionally for a communist newspaper, then worked for the Associated Press, then was noticed by Esquire *magazine. He worked for* LIFE *as well, and became the hotshot clearly seen here in a self-portrait with car.*

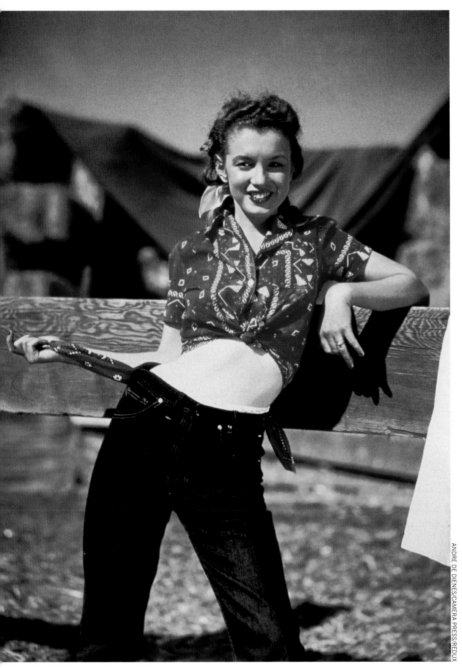

De Dienes (opposite) came in contact with Norma Jeane Baker in 1945 when she was a model on the books of Emmeline Snively's Blue Book Modeling Agency. The prospective project involved artistic nude shots, and Snively had told de Dienes of Norma Jeane—a new girl who might be right, and might be interested. Norma Jeane certainly did not blanch, and a meeting was arranged. In his memoir, de Dienes remembered that first encounter: "When Norma Jeane arrived at my bungalow later in the afternoon, it was as if a miracle had happened to me. Norma Jeane seemed to be like an angel. I could hardly believe it for a few moments. An earthly, sexy-looking angel! Sent expressly for me! The impact Norma Jeane had on me was tremendous. As minutes passed, I fell more and more in love with Norma Jeane; there was an immediate rapport between us. She responded to everything I said. She started to look around in my room examining all the pictures I put on the walls and began asking questions. I had the immediate feeling that she was something special, something different from most girls and models I had met before her, mainly because she was so eager to ask questions about me and the pictures I put on the walls. She wanted to know many things right away, she was interested in me! She was utterly sincere; she did not wish to speak about herself, except when I asked her my own questions. She was sincere in wanting to know who I was and what I was doing with my life, and I began to amuse her exceedingly with all sorts of stories that ran through my mind and I just kept dishing them out to her. I still remember it as clearly as if it happened just recently."

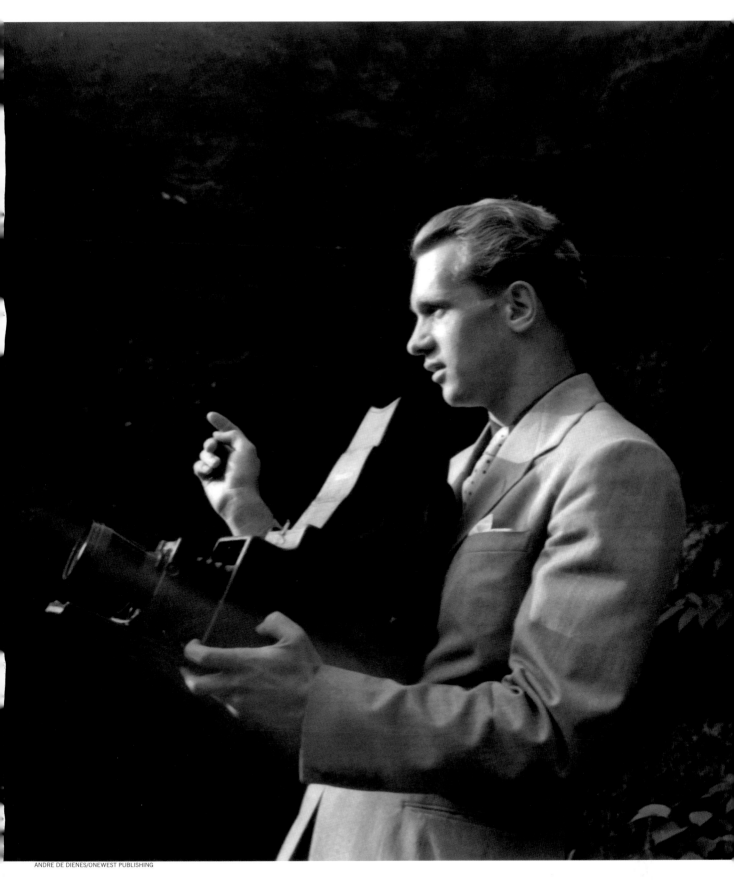

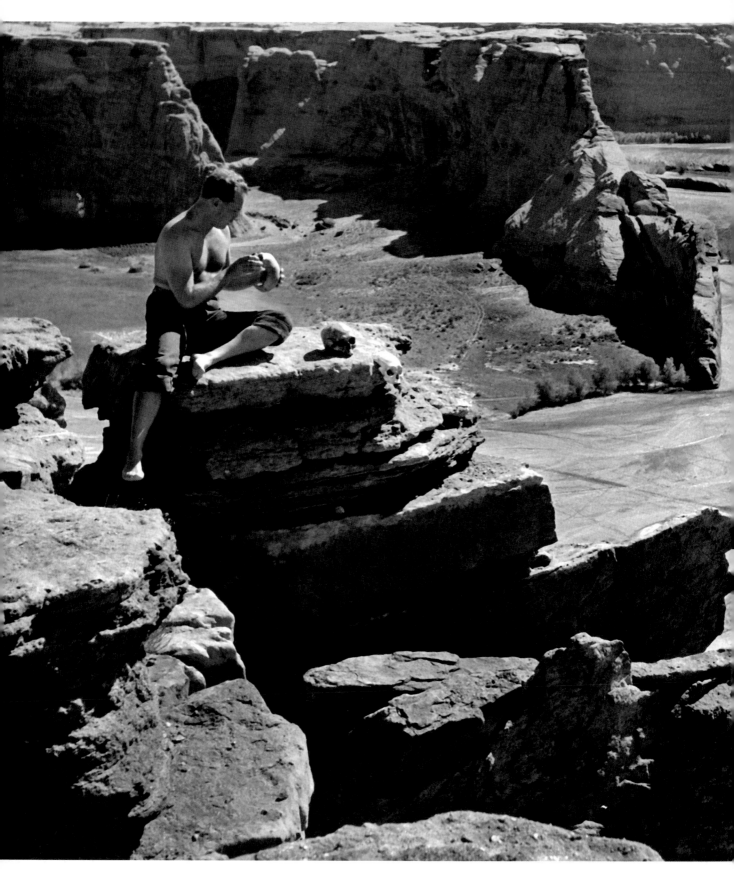

De Dienes (left) was talented and eclectic. After arriving in the U.S., he traveled west and photographed the day-to-day of Native Americans, including communities living on Apache, Hopi and Navajo reservations. Meanwhile, in New York, he was seen as a fashion photographer (his celebrity subjects would later include a host of A-listers: Taylor, Brando, Fonda, Bergman, Astaire, Ekberg, et al.). It might be said that he combined his twin visions in 1944 when he moved to California and began to gain a reputation for photographing nudes in sun-splashed landscapes. He was the right photographer at the right time for the woman about to become Marilyn Monroe. His first shots of this young aspiring star, who was about to separate from her husband, were taken on the beach in Malibu in 1945, and then de Dienes suggested a desert road trip. As the couple traveled in California, Nevada and Arizona, their love affair blossomed. Through the years, the desert pictures would prove a financial windfall for de Dienes, and he wouldn't share a dime of the proceeds with Monroe.

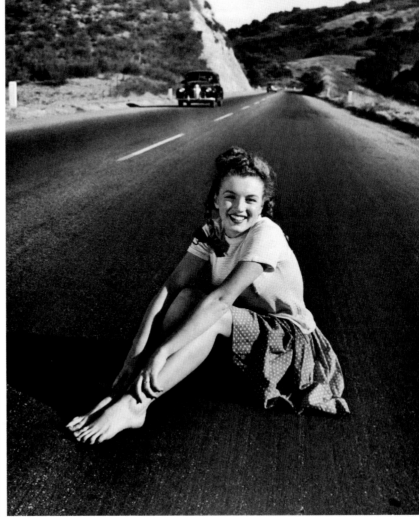

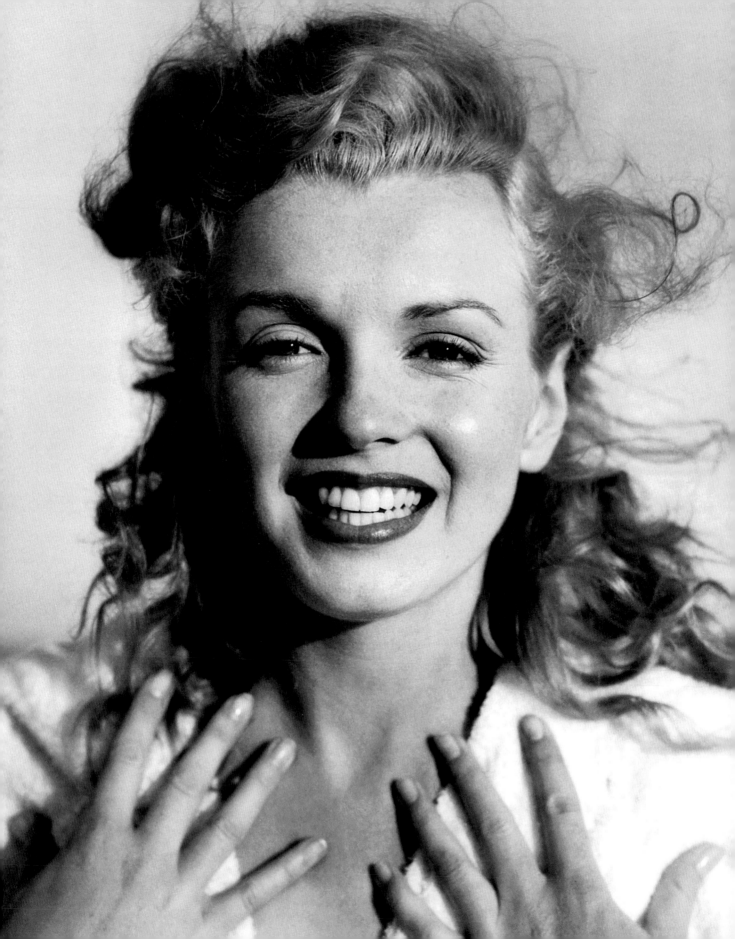

It was a point of pride with de Dienes that he was a man of strong professional and personal passions. He had certain rules: He never retouched his photographs but sought to capture in them what he considered true, natural beauty. He was, as were other men who would now parade through Marilyn Monroe's life, a strange guy. When he met Norma Jeane's mother he told her he was going to marry her daughter, which was news to the daughter. De Dienes and Monroe did not wed, of course, but his obsession endured long after they had come in from the road and had, then, gone their separate ways. (He would die in 1985.) The letter at right should be read in its entirety. It says a lot, somewhat amusingly, about this man's sense of himself and his approach not only to this woman but to life—and, incidentally, to LIFE. *Marilyn Monroe was, as they say, a piece of work. So were many of her lovers.*

ANDRE DE **Dienes** PHOTOGRAPHY

1401 SUNSET PLAZA DRIVE
HOLLYWOOD 46, CALIFORNIA
Olympic 2-6737

March 29, 60

Dear turkey foot:

I glanced through your biography in the April issue of McCall's and as usually, I did not find my name somewhere where it should have been mentioned - after all, I was a turning point in your life I always belived, and you yourself know it very well .

But I am not surprised you never mention me, for years now you did that same thing - got even with me . I shall never forget the incident when one Sunday we were driving along and had a short dispute about something, and I told you angrily " you will never be an actress " and you got out of the car at the next corner. Well, that's what did it I know, and perhaps other things.

I have no hard feeling toward you even if you never think of me, however I think it is a little bit funny that you did not mention all the lovely photos I took of you back in 45, 46, 47, 49, and so on.
Some day, when I will have time I shall write my memoires also, and will be kinder than you are and will mention you in it.

I have always been a disregt person, did not want to make lots of hallaballoo about things - I was wrong I admit it - while you made such an enormous story about yourself - or rather- others did it for you.
Well, that's the way life goes sometimes.

Incidentally, I left a short letter to you at your hotel a few weeks ago, wanted to photograph you for a magazine. You have probably left already, or was bored to do it, or perhaps you thohght thosose kind of lousy photos like I saw in Life magazine a week or so ago when the strike began at the Studio - will do you more good. Well, you looked pretty thin and old, and so did the other actors too in that layout. I was kind of peeved, how a great magazine like Life could send out a photographer to shoot such miserably looking photos.

Have to run now. Bless you, little mushroom - will see you some day - Am going up north this summer, through the redwoods, will think of you in the big forests.

regards,

Tommy Zahn

IN 1946, TOMMY ZAHN WAS A CALIFORNIA archetype: a handsome, sun-kissed surfer and lifeguard with blond hair and a body toned from endless hours in the sea. He was the avatar of beefcake; women encountering Zahn routinely melted. Darrylin Zanuck, daughter of 20th Century-Fox cofounder Darryl Zanuck, for instance, had seen Zahn on the beach. Taken with his beauty, she mentioned him to her father, who promptly signed him up as a big-screen heartthrob-in-training.

At Fox, Zahn met the young woman who had recently been christened Marilyn Monroe, and he became one of the few exceptions to her lifelong predilection for father figures. "She

Marilyn Monroe is rightly regarded as a legend and a goddess; she is No. 1 among celebrities and in the highest echelon of movie stars. Some of her paramours were legends and gods in their own right, in one case a titan in a more specific, somewhat smaller universe. Tommy Zahn, while perhaps not as big as, say, Duke Kahanamoku, is, in the world of surfing, still an icon (you can look him up). Zahn won the Catalina-to–Manhattan Beach paddleboard race in Southern California five times in the 1950s and early '60s: a very big deal. He hailed from there, naturally: born and raised in Santa Monica, a surfer by age eight, a lifeguard and a hunk by 18 (right, just chilling). After high school Zahn served in the Army as World War II wound down, then landed in Hawaii for a time, where he trained under Tom Blake, the inventor of the hollow surfboard. Finally, it was back to La-La Land and dates with destiny.

was in prime condition," Zahn, who was two years Monroe's senior, later said. "I used to take her surfing up at Malibu." Together, they took acting, singing and dancing lessons. They were, for a brief, gleaming, suntan-lotion-enhanced moment, what observers would call "a fun couple." But Monroe's drive was too great, and her relationship with Zahn can now be seen as her beach boy interlude. She was far more serious about acting than Zahn was. "My God, how I wanted to learn!" she said of the period. "To change, to improve! I didn't want anything else. Not men, not money, not love." So those things—which included Zahn—would go by the wayside as she sought to grow as an actress and build a career.

Despite her personal efforts at betterment, both she and Zahn were fired in short order from 20th Century-Fox. No reason was given, but Zahn had a theory: He believed Zanuck was grooming him for marriage to his daughter. Since the would-be union was threatened by his dalliance with Monroe, the two young hopefuls were sent packing.

They might have consoled one another briefly—the mists of history do not divulge this—but, anyway, they drifted apart.

Another interlude was awaiting. (Faced squarely, Marilyn's love life was one "interlude" after another.) And this next fellow would return for a later chapter, which may or may not have been an interlude of consequence. Read: matrimony.

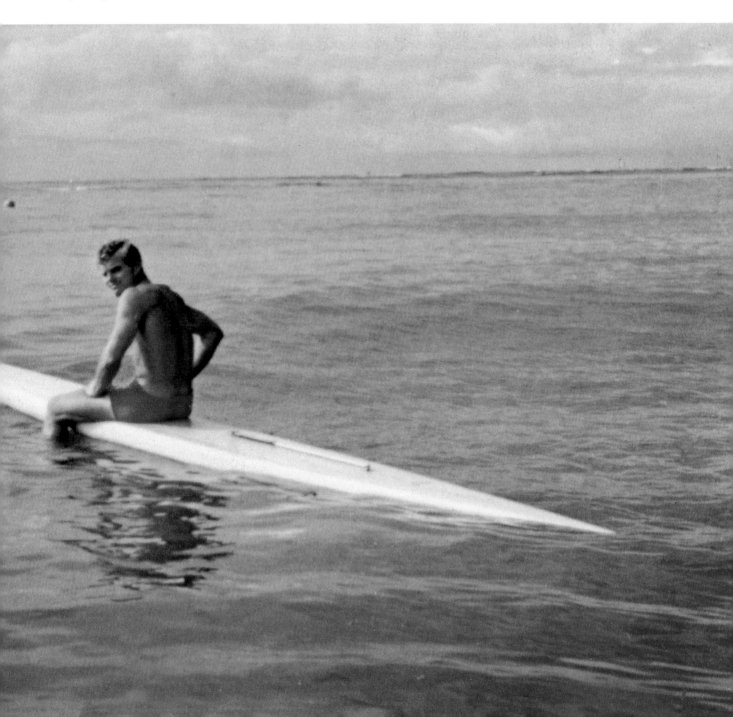

Tommy Zahn

*T*here were other women in Zahn's life before Marilyn, of course. Among them were members of Hollywood's elite. Zahn dated Darryl Zanuck's daughter Darrylin. She said she thought surfing was cool and she wanted to learn how to do it—a pre-Gidget Gidget—and Zahn asked local board maker Joe Quigg to build Darrylin an all-balsa surfboard that was thinner and lighter (by 25 pounds) than anything else available. Zahn called it the "Darrylin board," then started using it himself as it was exceedingly responsive and maneuverable. The board, which was the archetype of the revolutionary Malibu Chip design, helped Zahn pile up the trophies (below, he wins the yearly paddleboard race from Waikiki to Diamond Head buoy and back, circa 1958; opposite, he secures his board at Ali'i Beach Park on Oahu, in the late 1950s). He and Darrylin weren't destined to be a pair forever—who is, in Hollywood?—and after they split, into his life came Marilyn Monroe. He liked her plenty, but she never got a board named after her.

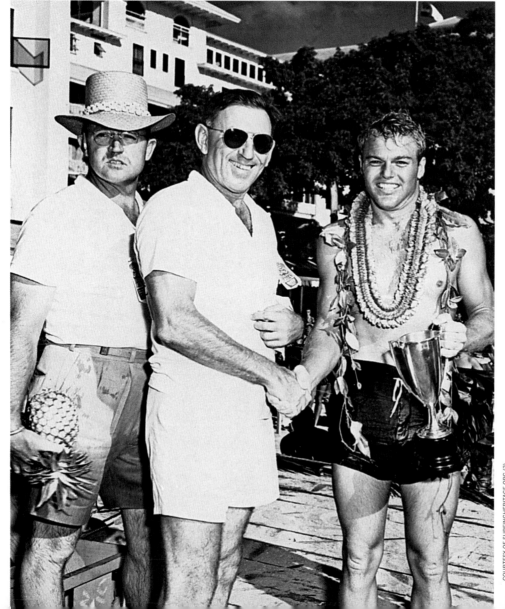

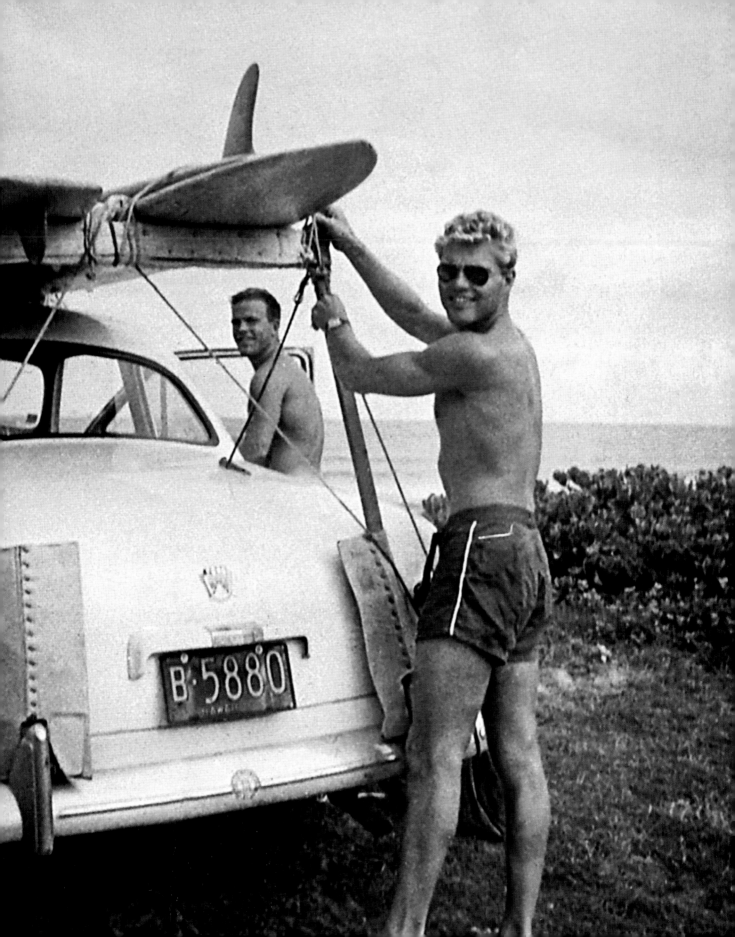

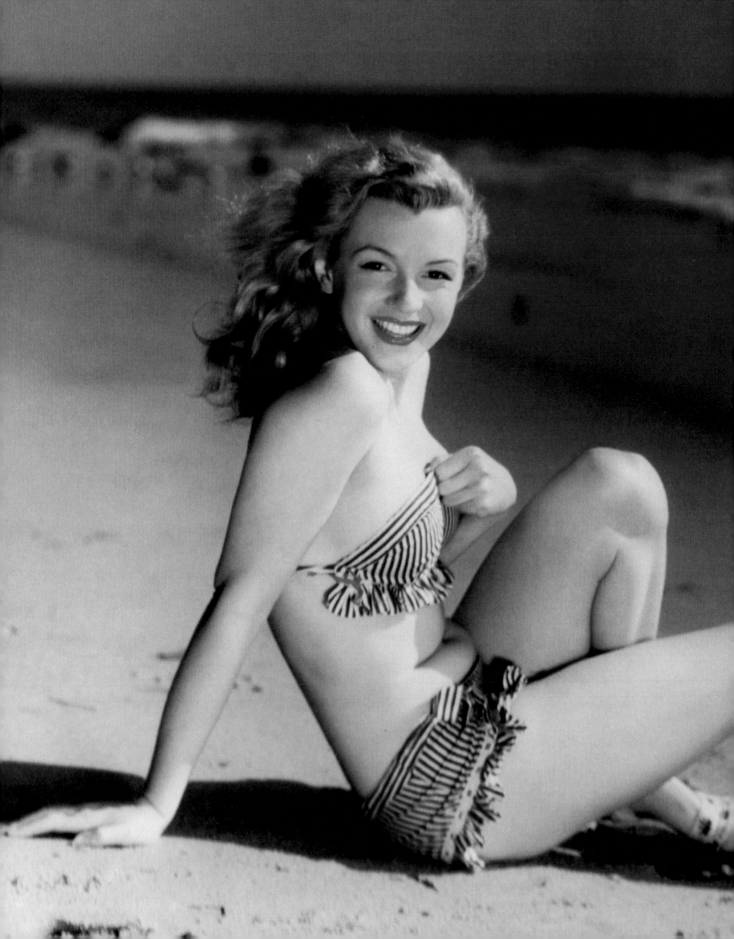

Tommy Zahn

She sure was pretty. It is suitable that in the Tommy Zahn period, Marilyn would enforce her reputation as an emphatically blonde bathing beauty—her guardian urged her to fashion herself as the new Jean Harlow—while sashaying Hollywood arm-in-arm with her male equivalent. In so many ways at that moment, Zahn was her perfect mate—except that he wasn't. "Swimming, surfing, paddling and a bit of rowing and outrigger canoeing was my thing," he wrote to a friend not long before his death from cancer at age 67. "Everything else in life didn't interest me much." This, from a former boyfriend of Marilyn Monroe! Goodness gracious. The actress and the surfer dude went their separate ways, and both would meet with controversy: Marilyn's, which is well known and which we will deal with; and Tommy's, which had to do with his views about, well, Aryan supremacy. Sometimes, apparently, a person can be too fit and too blond and can start thinking screwy things.

SUNSET BOULEVARD/CORBIS

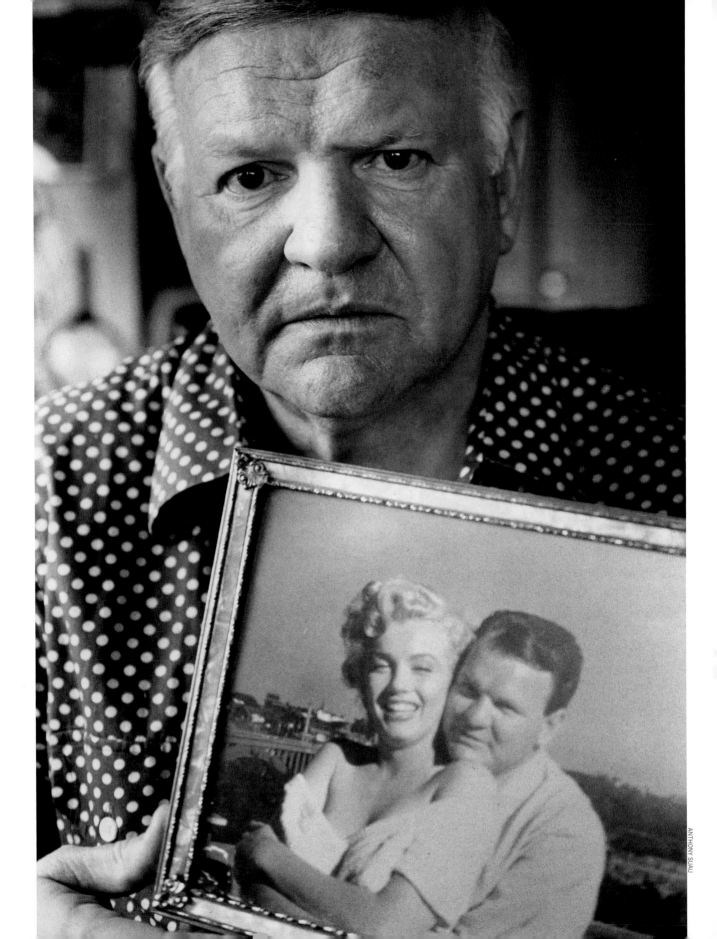

Robert Slatzer

ROBERT SLATZER WAS A 19-YEAR-OLD DRAMA CRITIC AND aspiring screenwriter from Columbus, Ohio, whom Monroe met in the lobby of 20th Century-Fox, where he was reading Walt Whitman's *Leaves of Grass* and waiting to interview the established star Gene Tierney. Unlike Zahn, he was not particularly handsome, but he represented the kind of cultured man the poorly educated and insecure Monroe always gravitated to. And needless to say, he gravitated to her. "She had a certain magic about her that was quite different," Slatzer said. "I guess you could say that my heart went out to her from that very first day—and she sensed that."

Slatzer always asserted that he had a lifelong relationship with Monroe. "We were friends, lovers, confidants," he wrote. They may also have been husband and wife—that was Slatzer's claim, as will be explained. For now, let's just say that Slatzer said they had the first of many good times together on the night of the day she interrupted his reading of Whitman. Whether he wooed her with verse from "I Sing the Body Electric" is to be doubted, simply because that would be too good to possibly be true.

On the opposite page is a 1985 photograph of Robert Slatzer holding a picture of himself and Monroe. Slatzer, who died in 2005 at age 77, met the starlet in 1946 and went to his grave claiming that he had married her in 1952, not long after they reunited during the filming of Niagara. He said that this photo proves it, and if you factor in Marilyn's lifelong sense of devil-may-care, his story certainly seems plausible. Slatzer, who wrote two books about the actress (The Life and Curious Death of Marilyn Monroe in 1974 and The Marilyn Files in 1992), asserted that he and Marilyn had tied the knot secretly in Mexico, then quickly "undid" their union when 20th Century-Fox Studios chieftain Darryl Zanuck told his employee Monroe that the whole affair was a bad idea—and a horrible career choice. All these years later, there is no independent confirmation of the marriage, so the facts of the matter remain that Norma Jeane/ Marilyn was married three times for sure, and maybe four.

J.R. EYERMAN

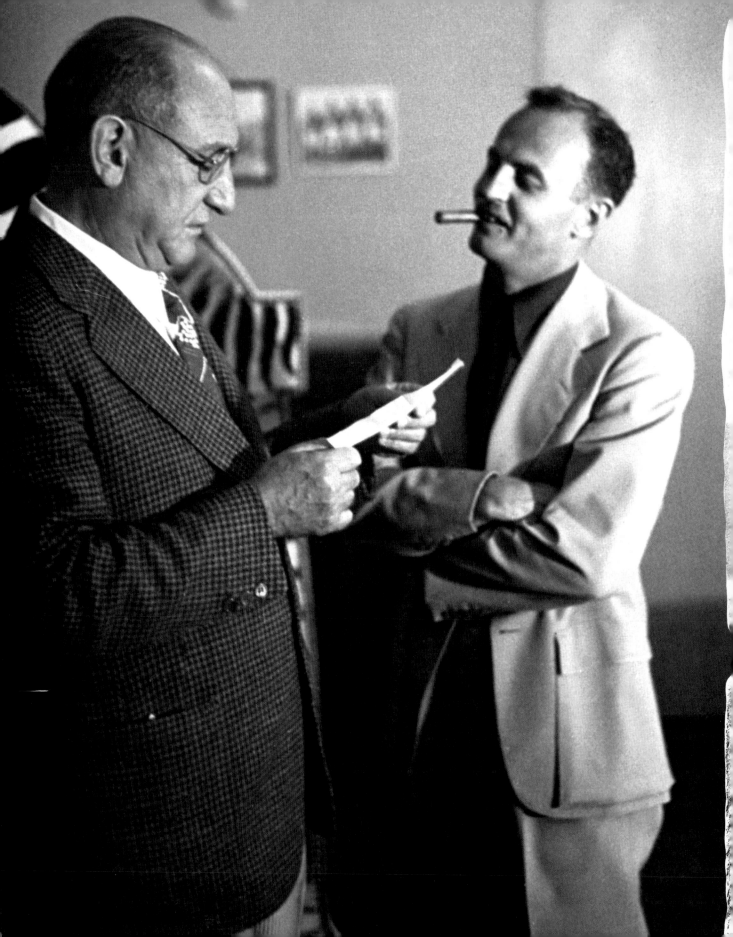

Joseph Schenck

A COFOUNDER OF 20TH CENTURY-FOX, JOSEPH SCHENCK WAS one of the architects of Hollywood—Marilyn said you could see Tinseltown's history in his face. In 1947, the 70-year-old was also a lover of beautiful young women. He invited a coterie of them, known as Schenck's Girls, to his Holmby Hills mansion to play cards and, rumor had it, provide sexual favors—when he could perform, which wasn't always. Monroe would become one of his favorite protégées. It seems likely that they were intimate. He clearly desired her—and she, in turn, sought his patronage.

Schenck may well have helped Monroe get her next big break, a contract at Harry Cohn's studio, Columbia. But here's a mystery: There are no known photos of Monroe from July 1947 until her career resumed at Columbia in early 1948, reports Donald H. Wolfe, author of 1998's *The Last Days of Marilyn Monroe*. Speculation exists that she gave up a child for adoption during that time. Her maid in New York, Lena Pepitone, claims Monroe gave birth to

Opposite: So we just talked, on the preceding pages, about the omnipotent Darryl Zanuck stepping in and scuttling Marilyn's maybe-marriage to Bob Slatzer, and here Zanuck is, puffing on a cigar in mogulesque fashion and talking with Joe Schenck (left) in 1938. Down the road, these two men would have much to say about the career (and, indeed, the life) of Marilyn Monroe, just as it took an early crucial turn toward stardom. Schenck in fact got Marilyn her first movie role, a tiny part in 1948's Fox film Scudda Hoo! Scudda Hay! *(right, with a shirtless Lon McCallister), in which Monroe delivers her first (and, in that movie, only) on-screen line: "Hi, Rad." She is addressing the character played by the film's star, June Haver. Incidentally, in a larger role than Marilyn's was Natalie Wood, age nine, who already was enjoying a career as a child star, having made the previous year's* Miracle on 34th Street.

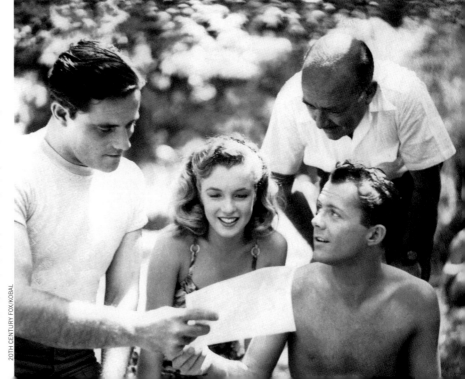

a daughter before she achieved stardom, and that she had last-minute second thoughts before letting go of the child. "I begged them," Pepitone says Monroe told her, "'Don't take my baby!'"

In 1947, Monroe began dating Charlie Chaplin—not the legendary comedian but rather his troubled son, also named Charlie. He was a tragic character, largely unloved by his genius father, struggling to forge a career as an actor in his own right and drinking to excess. He was overwhelmed by Monroe, but the couple split when he returned to the home that he shared with his brother Sydney and found the two of them in bed.

During this time, Monroe also began taking acting lessons from Columbia's head drama coach, the German-born Natasha Lytess, an actress whose career had been interrupted by World War II. Later, Monroe and Lytess shared an apartment. Some have even suggested they had an affair. Responding to rumors that she herself may have been a lesbian, Monroe coyly said, "No sex is wrong if it has love in it." However, it was claimed the star was uncomfortable with homosexuality, despite her friendships with many gay men, including Truman Capote and Montgomery Clift. "She had an outright phobia of homosexuality," said Ralph Greenson, her psychiatrist. In a diary found after her death, she wrote of her friend Peter Lawford: "The real reason I was afraid of him—is because I believe him to be homosexual."

*O*pposite: *Charles Chaplin Jr. is at an Army induction station in Los Angeles on October 1, 1943, where he is to undergo a physical exam. He will pass and will fight in Europe during World War II. That—even accounting for his relationship with Monroe—will represent one of the more positive episodes in an otherwise sad and short life. His mother was Charlie Chaplin's second wife, the American Lita Grey; and when he was just a child, Charlie Jr. was caught up in his parents' bitter and very public divorce. He was raised principally by his mom, though he did appear with his dad in the 1952 classic* Limelight—*a bright spot in his otherwise undistinguished eight-film movie career. In '58 he married the actress Susan Magness, with whom he had a daughter, but they divorced right away, in '59. A decade later, Chaplin died at age 42 after suffering a pulmonary embolism. Right: In 1949, starlet Monroe, 22, takes lessons from acting coach Natasha Lytess, who would tutor Marilyn for several years before being dismissed in favor of Lee and Paula Strasberg. Whether Lytess and Monroe's was more than a teacher-pupil relationship remains uncertain.*

J.R. EYERMAN

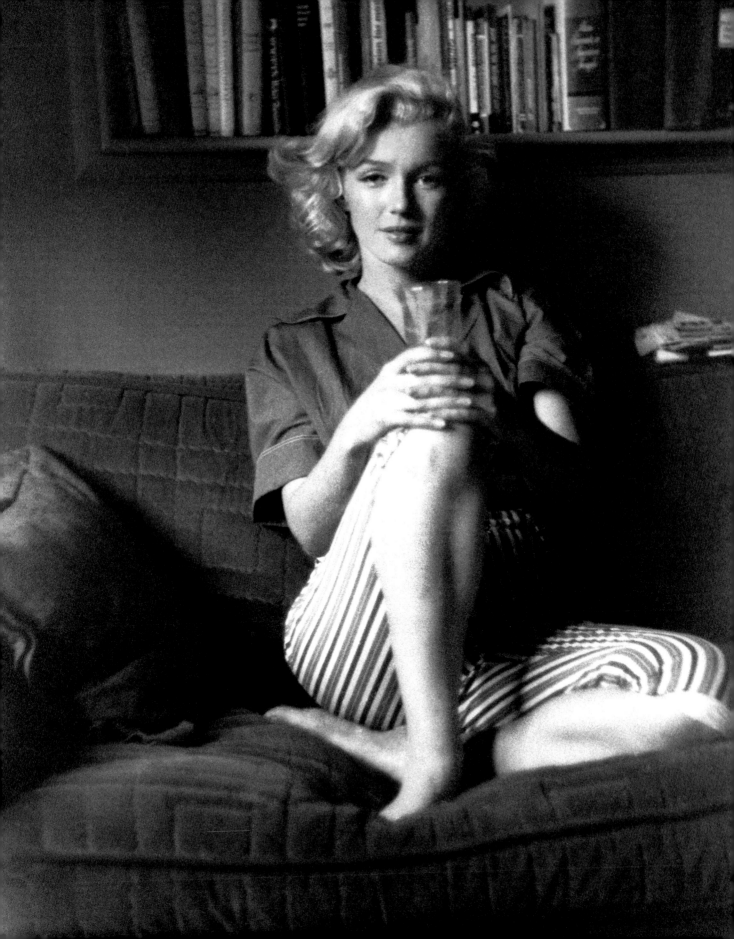

The men we meet in these several pages—Schenck, Fred Karger, Johnny Hyde—play loose with the notion of mentor. They were seen as such, in relation to Monroe, by their confreres in Hollywood. But whether each might have been more accurately termed a mentor/boyfriend or a boyfriend/mentor (or, to throw in the mysterious Natasha Lytess, possible girlfriend/mentor) remains debatable. In any case: Opposite is Monroe in October 1953 at Schenck's villa, in a photograph taken by her friend Milton Greene. The official caption for this picture: "Marilyn looks radiant even when taking a break. Completely casual in striped capris and barefoot, Marilyn holds a glass on her knee while seated on a couch beneath a bookshelf." Below: She and Schenck, seated between columnists Louella Parsons and Walter Winchell, are hardly "completely casual" that same month at a party thrown at the famous Ciro's in West Hollywood for the benefit of the Damon Runyon Cancer Memorial Fund. Marilyn is, by now, expected to be seen at such events, and she is ogled by everyone in the room.

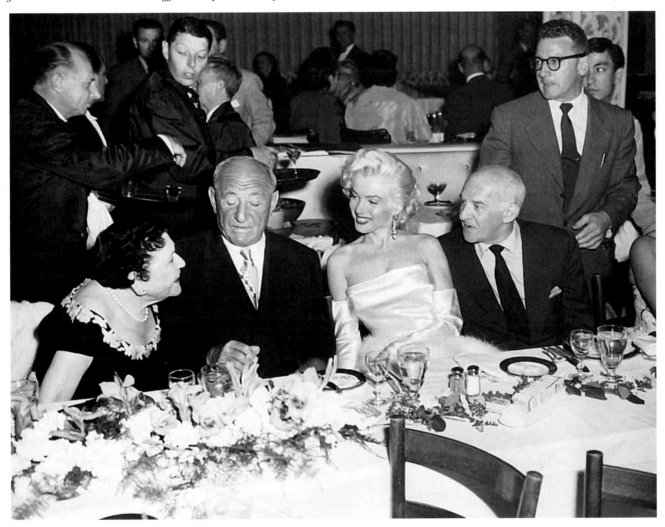

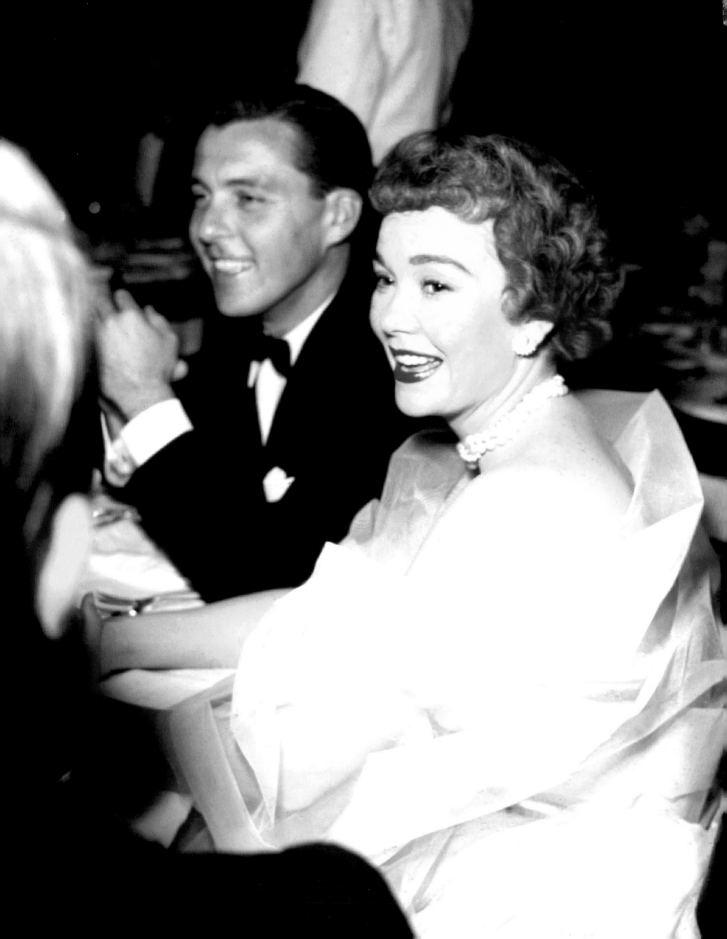

Fred Karger

THE CLASSICALLY HANDSOME FRED KARGER, A COMPOSER and arranger at Columbia, had been hired as Monroe's vocal coach for 1948's *Ladies of the Chorus*. He was 10 years older than she and the divorced father of one daughter. There's a case to be made that he was the great unrequited love of Marilyn's life. "When Freddy said, 'I love you' to me, it was better than a thousand critics calling me a great star," the smitten Monroe said. "All the fame and bright colors and genius I had dreamed of were suddenly in *me*!"

But Karger never took their relationship seriously. Nor did he fully respect Monroe. "Your mind isn't developed," he once told her. "Compared to your breasts, it's embryonic." (Marilyn couldn't argue—she didn't know what *embryonic* meant.) Karger was critical of the star—at times cruelly so. He once told her that he couldn't marry her because, in the event of his death, he didn't want his daughter being brought up by "a woman like you." For Monroe, who desperately wanted to be taken seriously—and to have children—this was devastating.

Karger's professional ministrations clearly helped Monroe—one critic, emblematic of others, would single out her singing as one of the "brightest spots" in an otherwise tepid film—but in the end he broke her heart. When it became clear that their relationship was over, she bought him a $500 watch that she could not afford. It was inscribed not with her name but with the date "12/25/48"—that way, she said, he could wear it when he dated other women—a reminder. He soon went on to marry the actress Jane Wyman.

Monroe was, upon Karger's departure, in a career as well as a personal slump, having been dropped just then by Columbia. When her option for renewal had come up, the studio's president, Harry Cohn, invited her for a private voyage on his yacht. She later claimed she told him she wouldn't go unless his wife was there. According to Monroe, Cohn's response was, "What makes you think you're so special?" Then he showed her the door.

Monroe later said: "Yes, there was something special about me, and I knew what it was. I was the kind of girl people expect to find dead in a hall bedroom with an empty bottle of sleeping pills in her hand. But things weren't entirely black. They never really are. When you're young and healthy, you can plan on Monday to commit suicide, and by Wednesday you're laughing again."

This picture, opposite, is pretty obviously not of Monroe and Fred Karger; it is in fact of Karger and his wife, Jane Wyman, in the early 1950s, not too very long after his relationship with Monroe has ended (as has Wyman's marriage to Ronald Reagan). Photos of Karger and Monroe together are scarce to nonexistent, not least because the music director deemed his platinum-haired lover unsuitable to be seen with in public, while nevertheless taking advantage of her privately. Perhaps Wyman was his comeuppance. She married him in 1952; they divorced in '54; then they re-wed in '63; and in '65 she, according to what Karger told the Los Angeles Superior Court, walked out on him a final time. Incidentally, Reagan felt the same way about how Wyman had ended their eight-year marriage. Needless to say, Marilyn Monroe was not the only denizen of Hollywood with a complicated love-life.

Johnny Hyde

JOHNNY HYDE, A FORMER VAUDEVILLIAN, WAS A WEALTHY
Hollywood agent with a keen eye for beautiful women. (His eternal claim to
fame was his discovery of Lana Turner.) When he met Monroe in 1949, he
fell fast and hard. At 53, he threw himself into promoting his new obsession.
He arranged to have her nose straightened, bought her clothes, introduced
her to power players and wined and dined her at the glittering Hollywood
restaurant Romanoff's. Most important, he helped her score her first part in
a major movie—the John Huston film noir *The Asphalt Jungle,* today a classic.

Hyde's pursuit of Monroe was frantic. He left his wife and asked the actress
to marry him. Were she so inclined, she could have done it and inherited his
fortune, knowing that, with his chronic heart trouble, Hyde probably did not
have long to live. But "he needed something I didn't have—love," she said.
"And love is something you can't invent, no matter how much you want to."

Hyde continued to promote her, regardless. On the heels of her small but
stellar performances in *The Asphalt Jungle* and, later, *All About Eve,* he fina-
gled her return to Fox, where he negotiated a seven-year contract. A grateful
Monroe was with him when he died on December 18, 1950, at Cedars of
Lebanon hospital.

The loss affected her deeply. Six days after his death—on Christmas Eve—
Natasha Lytess found Monroe unconscious in the apartment they now shared.
"Marilyn was in bed, undressed," Lytess said, "her cheeks puffed out like an
adder's." She had overdosed. By the actress's own admission, it was not the
first time: She had tried to kill herself twice in her teens.

Monroe was still mourning Hyde on the set of her new movie, *As Young As
You Feel,* when she met a man whom she would later marry. The playwright
Arthur Miller had traveled to Los Angeles with the director Elia Kazan,
who was also one of Monroe's lovers ("He *loved* me for one year and once
rocked me to sleep one night when I was in great anguish," she wrote of
Kazan). Miller and Kazan were in California to set up a film called *The Hook* at
Columbia. Seeing the actress in tears, Miller was immediately overwhelmed.
"When we shook hands, the shock of her body's motion sped through me,"
he wrote in his 1987 memoir, *Timebends,* "a sensation at odds with her sadness

*We include the man pictured
poolside in 1950 with Monroe
as one of the "loves of Marilyn"
because he loved her so deeply,
though we cannot confirm absolutely that Hyde
was ever her lover. While it has been written
that the married man tried to woo Monroe and
succumbed to her, she herself asserted that
there was no affair. All the same, the powerful
Hollywood agent helped the actress greatly. By
the time he began working with Monroe, she
had already lost her first studio contract and
was foundering in her quest for stardom. Hyde
suggested some plastic surgery on her chin
and urged her to bleach her hair platinum on
regular occasion. He then used his great influ-
ence to get her important roles in* **The Asphalt
Jungle** *and* **All About Eve** *and helped secure
that second contract with Fox—critical deals
that would position her for all the success that
followed.*

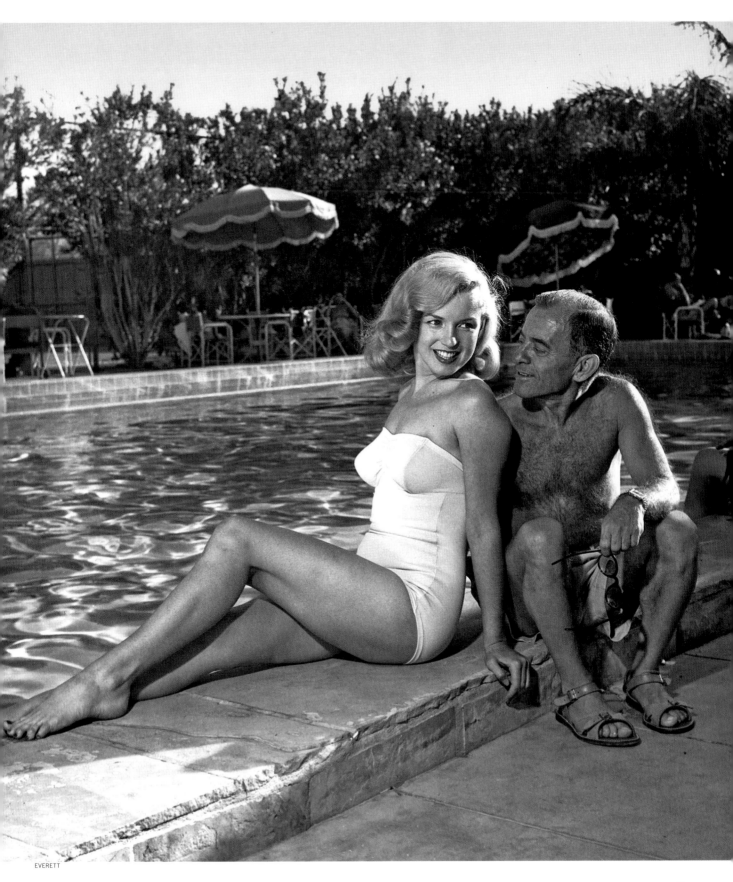

Johnny Hyde

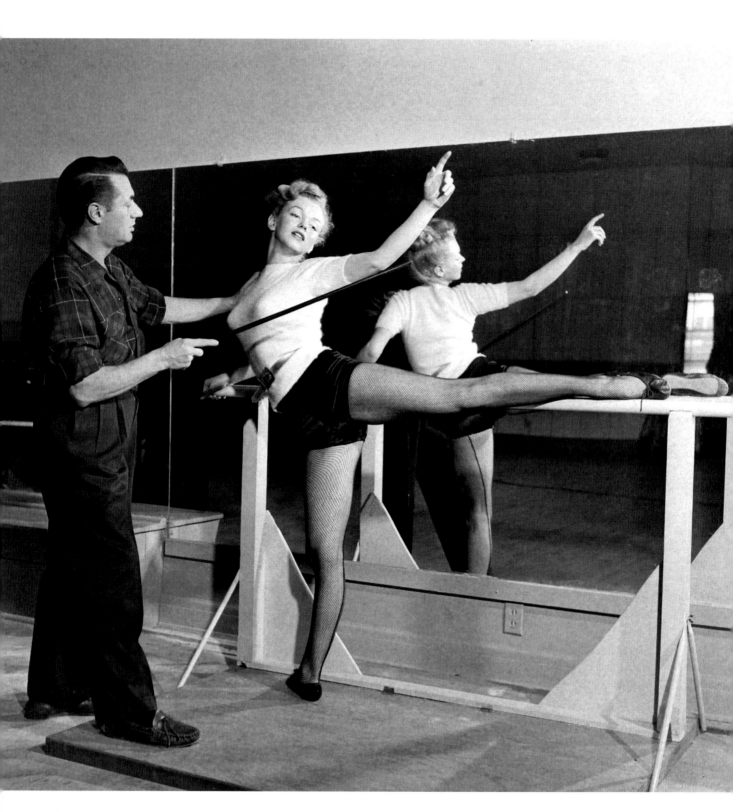

onroe, in the years before her dissolution, was a hard worker and a sponge of a student. Here she is seen during two tutorials, studying ballet with Greek-born dance instructor Nico Charisse in November 1948 and then, that same month, in a voice lesson with jazz musician and bandleader Phil Moore at the Mocambo nightclub in West Hollywood. Another dance coach who worked with her in this period, Jack Cole, once paid tribute to her avidity as a student and her quest for self-improvement, even perfection: "She is always looking for more time—a hem out of line, a mussed hair, a scene to discuss, anything to stall facing the specter, the terrible thing of doing something for which she feels inadequate . . . She wants to do it like it's never been done before."

amid all this glamour and technology." At that time, he was torn between familial duty (he was a husband and a father of two) and a powerful attraction to this woman who seemed the embodiment of both sex and childlike vulnerability. "I had to get out," he wrote. "I desperately wanted her and I decided I must leave tonight, if possible, or I would lose myself here."

Courting the loss, he dallied in L.A., spending time with Kazan and Monroe, sharing drinks and visiting friends. In a bookstore, Miller gave her a volume of poetry by E.E. Cummings and was struck by her delight in the writing: "I could not place her in any world I knew." She was "like a cork bobbing on the ocean, she could have begun her voyage on the other side of the world or a hundred yards down the beach."

A few days later, Miller finally tore himself away, flying back east to rejoin his family. Monroe accompanied him to the airport. "The sight of her was something like pain," Miller wrote, "and I knew that I must flee or walk into a doom beyond all knowing."

That doom was five years away, on the other side of Monroe's second marriage.

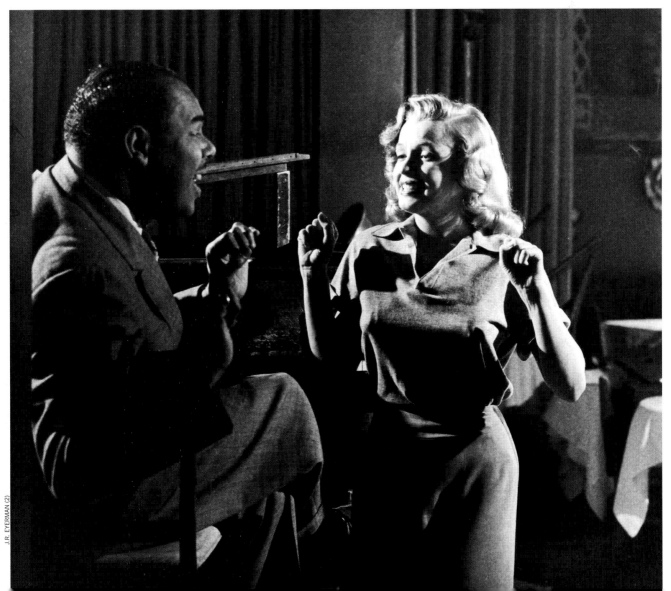

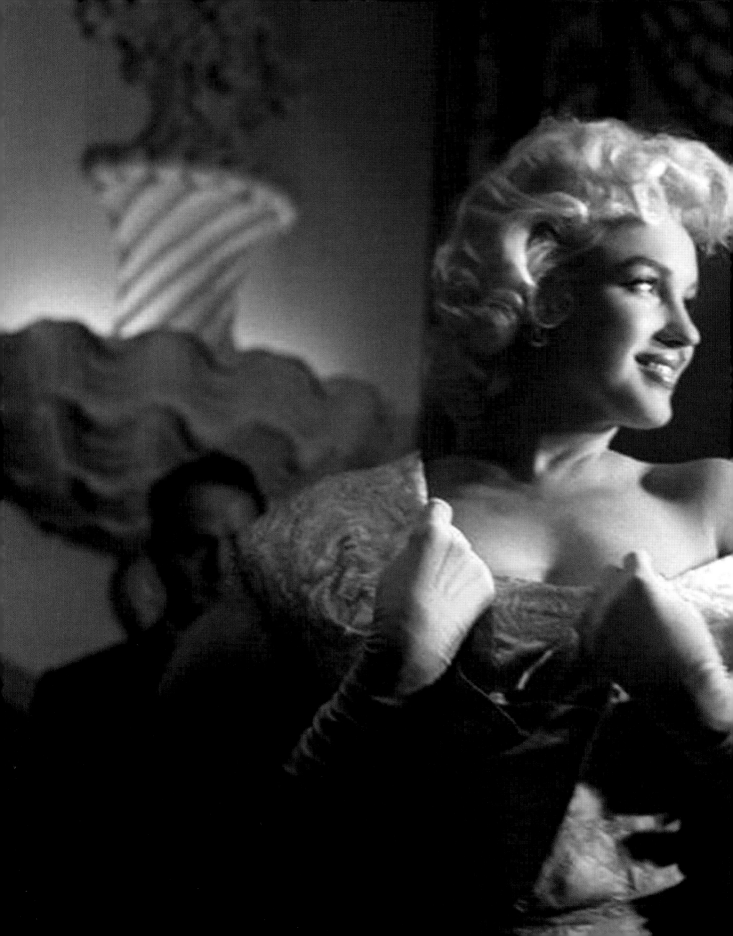

*I*nconceivably beautiful and almost impossibly blonde, Marilyn Monroe, whether she was on-screen or appearing at a fete (here, at a New York City premiere), was a role the inner Norma Jeane was well aware she was playing. She later said, "I used to get the feeling, and sometimes I still get it, that sometimes I was fooling somebody. I don't know who or what—maybe myself." In a variation on that theme, she also said, "I feel as though it's all happening to someone right next to me. I'm close—I can feel it, I can hear it—but it isn't really me." It could be wondrous and it could be awful to be Marilyn Monroe. It was also, almost always, strange and disorienting.

C 8668

C 8670

C 8671

C 8673

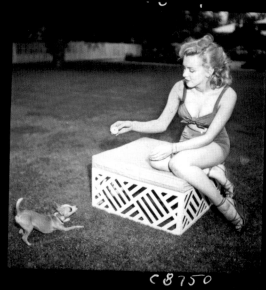

C 8750

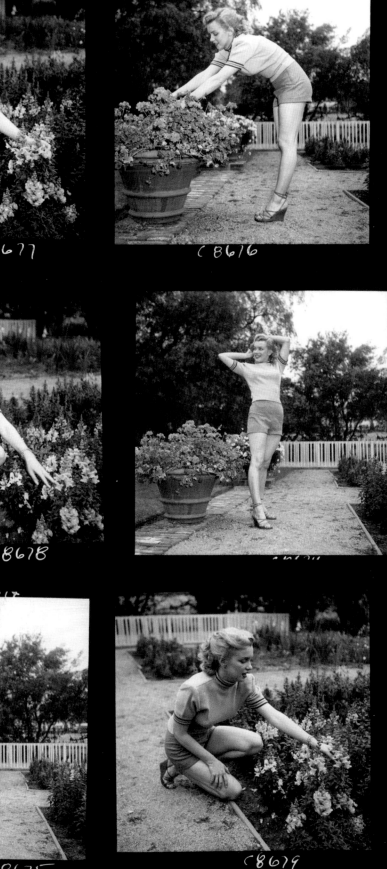

The images on the contact sheet—as well as the one that leads this chapter and the picture on page 51—were taken on May 17, 1950, in the backyard of Johnny Hyde's home at 718 North Palm Drive in Beverly Hills, where the agent made a series of photographs that would be used in spreading the word about Monroe. (Lost to the mists of time are Monroe's possible talents as a gardener or confirmation of her affection for Chihuahuas.) Hyde's pictures did the trick with magazine editors and the public, and so did an even more famous photograph that ran in this period (and that we refrain from reprinting). In 1949, the then-struggling actress had posed nude for a calendar for the sum of $50. Soon after, Fox executives were hearing rumors that the extravagantly naked blonde in the ubiquitous pinup shot—a shot that would gain even wider currency the following year when it was selected as the first Sweetheart of the Month centerfold in the debut issue of Playboy magazine—was none other than their young starlet. In addressing the brewing scandal with a reporter from the United Press wire service, Monroe, having learned her lessons well from Hyde, exhibited a disarming cheerfulness that played well with her growing public. "Why deny it? You can get one anyplace," she said of the calendar. "Besides, I'm not ashamed of it. I've done nothing wrong." Right you are, agreed a majority of moviegoers, with an overwhelming majority of the yea-sayers being male.

Here are two more photos taken for Hyde. As said, Johnny died in December 1950, but he would have been delighted by how the publicity cycle he set in motion continued to play out. Monroe was not only chosen as Playboy's Sweetheart of the Month but, from 1951 to 1953, was named Miss Cheesecake of 1951 by **The Stars and Stripes** newspaper; the Present All GIs Would Like to Find in Their Christmas Stocking, by voting members of the armed services; World Film Favorite, by members of the Hollywood foreign press; the Girl Most Likely to Thaw Alaska, by soldiers stationed in the Aleutians; the Girl Most Wanted to Examine, by the 7th Division Medical Corps; the Girl They Would Most Like to Intercept, by All Weather Fighter Squadron 3; Cheesecake Queen of 1952, again by **The Stars and Stripes**; the Most Promising Female Newcomer of 1952, by **Look** magazine; the Most Advertised Girl in the World, by the Advertising Association of the West; the Fastest Rising Star of 1952, by **Photoplay** magazine; the Best Young Box Office Personality, by **Redbook** magazine; and the Best Friend a Diamond Ever Had, by the Jewelry Academy. Her first appearance on the cover of LIFE came on April 7, 1952, a Philippe Halsman portrait with the simple cover line THE TALK OF HOLLYWOOD. From high above in heaven (perhaps), Johnny Hyde smiled.

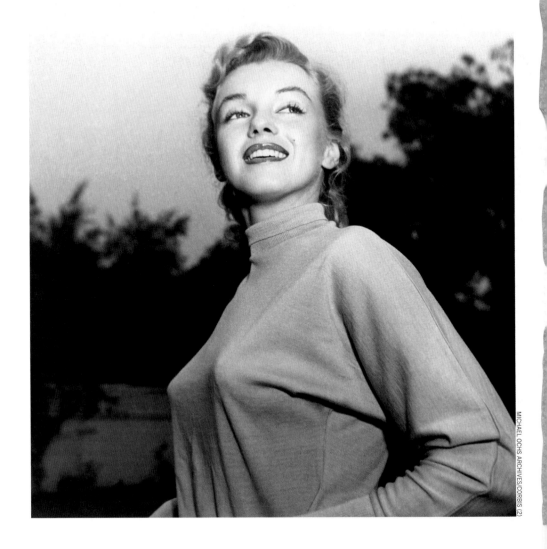

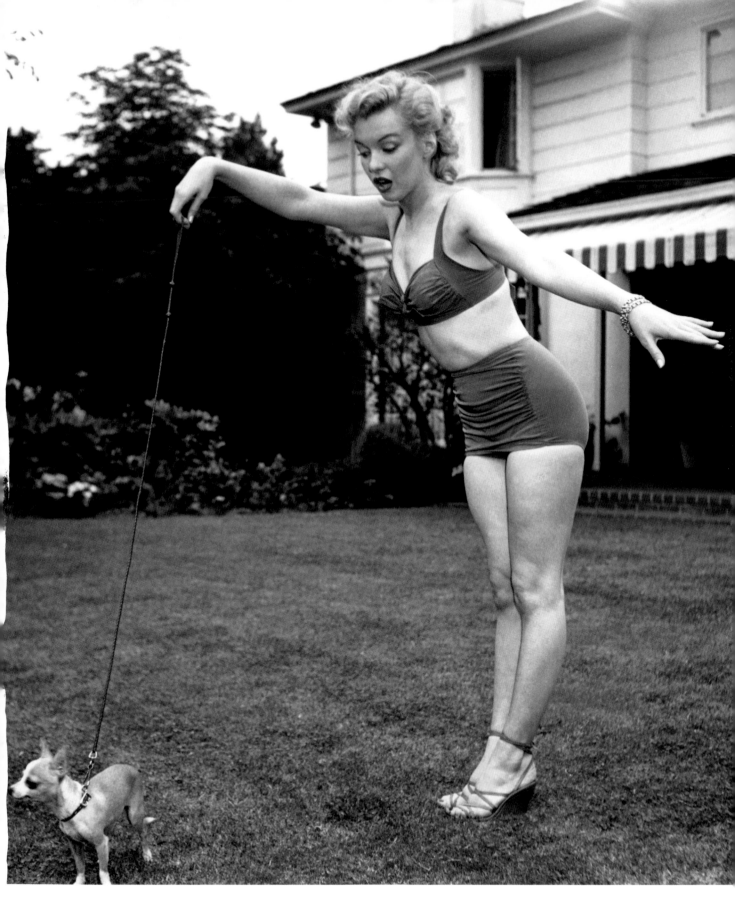

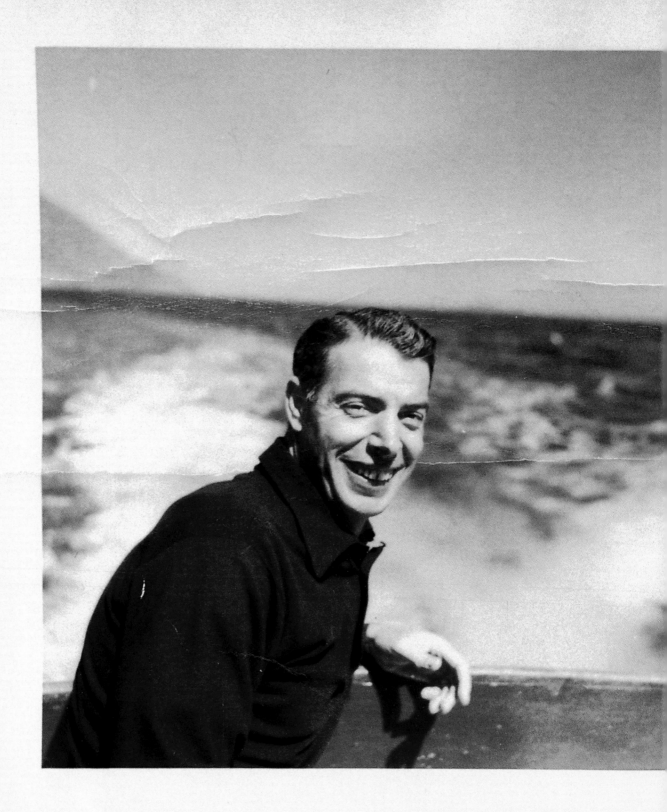

Joe DiMaggio

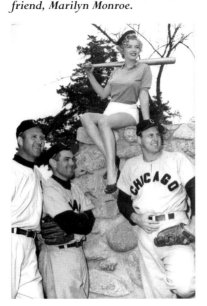

Marilyn plays ball (below) with, from left, Joe Dobson, Henry Majeski and Gus Zernial at the Chicago White Sox spring training camp in Pasadena, California. This is one of the photographs that caught the eye of Joe DiMaggio, and he got Zernial on the horn quickly enough. The Yankee Clipper is seen clipping along, at left, in California's Bodega Bay, in 1953. This snapshot was taken by his girl-friend, Marilyn Monroe.

IN APRIL 1952, MONROE APPEARED FOR THE first time on the cover of LIFE in a portrait shot by our legendary photographer Philippe Halsman. More of Halsman's pictures appeared inside. But another series of photos taken around the same time would have an even more profound impact on Monroe's life, if not her career. In these setups, Monroe clowns around with a baseball bat while wearing a beret, high heels and shorts, as Chicago White Sox players look stiffly on. Joe DiMaggio, the 37-year-old freshly retired New York Yankees superstar, chanced upon the published spread and rang up one of the Sox players, Gus Zernial. How could he meet Marilyn Monroe?

The rising star and the erstwhile slugger were eventually introduced by another of DiMaggio's friends, an agent named David March. When March called Monroe, she was initially uninterested—she figured DiMaggio would be "sporty" and "loud." But she agreed to a date at the Villa Nova restaurant (now the Rainbow Bar and Grill) on West Hollywood's Sunset Boulevard.

Characteristically, the actress was late in arriving, but she was pleasantly surprised when she sat down and started to chat. "There was no denying I felt attracted," she said, "but I couldn't figure out by what." She thought it might have something to do with the "excitement" in DiMaggio's eyes. Afterward, DiMaggio asked her to show him the city, and before long they started dating. He took her to see his family in San Francisco, introducing her to the Sicilian fisherman culture in which he'd grown up.

As the relationship deepened, it became evident that this proud, traditional man would want the spirited, independent Hollywood star—the most famous woman in the world—to be a stay-at-home wife if she became Mrs. DiMaggio. The idea perhaps appealed to Monroe at first; she may have tried it on for size, the way she might a film role. But nothing about the complicated, difficult and restless woman who was Monroe would be suited for what she would consider a life of dull domesticity. "I've always had too much fantasy to be only a housewife," she would tell LIFE magazine in an interview shortly before she died. That was truer and more self-aware

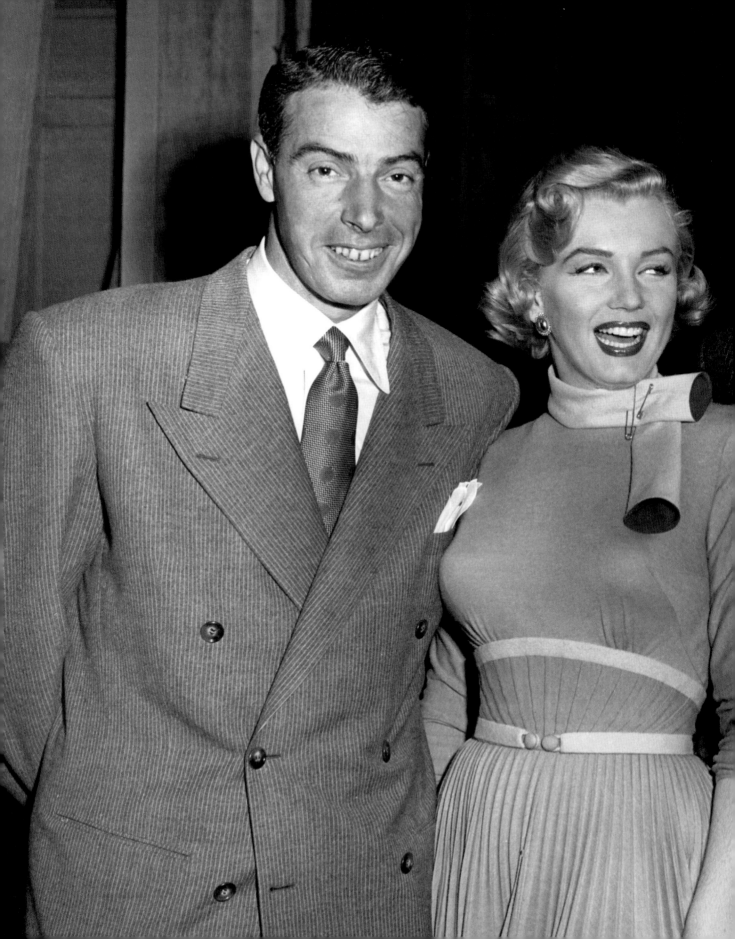

than what she told the press at the time, after she said yes to DiMaggio on New Year's Eve, 1953. "Marriage," she said, "is my main career from now on."

Monroe certainly issued such statements to please DiMaggio, and as well to assuage what she already knew to be his chronic, often violent jealousy. Before the marriage, she played with fire, sleeping with other men even as she was courted by DiMaggio—among them the actor Nico Minardos, whom she saw on and off for seven months during 1952 and who piggishly called her "a lousy lay"; Spyros Skouras, the president of 20th Century-Fox; Edward G. Robinson Jr., the alcoholic son of the famous actor; Billy Travilla, her costume designer; and—perhaps most significantly—Robert Slatzer again. In the summer of 1952, Slatzer had joined Monroe on the set of *Niagara,* staying in a room next to hers at the General Brock Hotel in Niagara Falls, New York. The two had become drinking buddies, and during one bender they decided it might be fun to get married. Slatzer later claimed they went through with it in Tijuana, and while there is no hard evidence of this, the biographer Anthony Summers lends the story credence by quoting witnesses, including the actress

(continued on page 61)

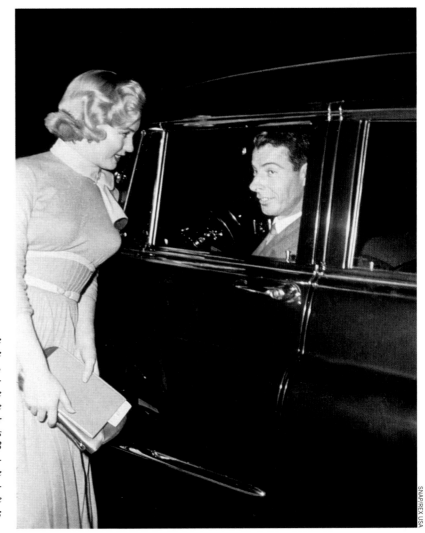

These are two shots from 1952, the one on the opposite page taken on the set of **Monkey Business.** *Marilyn was, by now, developing or cementing reputations. Everyone was conceding her status as the world's preeminent sex symbol. Although she would eventually be accorded praise for her acting and singing, for the moment she was considered, basically, va-va-voom. In the 1953 film noir* **Niagara,** *Monroe electrified audiences if not critics with her portrayal of Rose Loomis, an adulterous wife who plots her husband's murder. (Even as she made the film, she was either marrying Bob Slatzer or she wasn't; cheating on DiMaggio or not.)*

Joe DiMaggio

*D*iMaggio wasn't the only ath-
lete in this relationship; in
1952, Monroe works on her
increasingly famous physique.
*This is how folks saw her, and wanted to see
her, at this point in time. In Niagara, her quiet,
smoldering rendition of the song "Kiss" and
an extended shot of her wavering caboose as
she ambled away from the camera—regarded
as "the longest walk in movie history"—were
takeaway memories.* The New York Times
*wrote, "Obviously ignoring the idea that there
are Seven Wonders of the World, Twentieth
Century-Fox has discovered two more and
enhanced them with Technicolor in 'Niagara'
. . . For the producers are making full use of
both the grandeur of the Falls and its adjacent
areas as well as the grandeur that is Marilyn
Monroe."*

This photo is as lovely as any of the couple. When they started dating, in 1952, she was 25 and DiMaggio was 37. He was newly retired from his trade, baseball, and she was on the rise in hers, acting, having received good notices for her parts in The Asphalt Jungle *and 1952's* Clash by Night. *She was given her first lead that year, in* Don't Bother to Knock. *She later said, "I was surprised to be so crazy about Joe. I expected a flashy New York sports type, and instead I met this reserved guy who didn't make a pass at me right away . . . He treated me like something special. Joe is a very decent man, and he makes other people feel decent, too." She also said at this time: "I want to be a big star more than anything. It's something precious."*

Terry Moore. If the marriage did occur, it endured for only a few days—either because Monroe had second thoughts or the studio insisted she bail out. "Whenever Marilyn was teased about the marriage, she would say it lasted longer than most Broadway plays," Slatzer said.

DiMaggio wasn't happy about any of this and Monroe knew it, but she was not yet his wife. Now, after a January 14, 1954, wedding at San Francisco's City Hall, she was.

The couple honeymooned in Japan during a business trip that the Yankee Clipper had already scheduled. Despite Monroe's public declarations, marriage was clearly *not* her main career; and when she was invited by the Far East Army Command to perform for the troops in Korea, she was eager to comply. "Go if you want to," an angry DiMaggio told her. "It's your honeymoon!"

Monroe stayed in Korea for four days, basking in the rabid reaction of thousands of servicemen. DiMaggio, although forewarned, was nonetheless stunned by his wife's unbridled exhibitionism, which included tucking skirts into her derriere and literally being sewn into outfits to emphasize her bust. "It's no fun," said the old-school Sicilian, "being married to an electric light."

His anger shot past the boiling point that September when he watched Marilyn shooting the famous skirt-lifting scene from Billy Wilder's *The Seven Year Itch*. ("Oooh, do you feel the breeze from the subway? Isn't it delicious?") As thousands of onlookers gathered after midnight at 52nd Street and Lexington Avenue in New York City, DiMaggio stood by and steamed. His face had, Wilder later said, "the look of death." That night at the St. Regis hotel, where the DiMaggios were staying, what sounded like violent fighting was heard from their room. When Marilyn appeared the next day covered with bruises, speculation swirled that her husband had beaten her. It

(continued on page 64)

*I*n late 1953, for the upcoming holiday issue of LIFE's rival, Look magazine, editor Fleur Cowles wanted to do a movie number. Rupert Allan, Look's West Coast editor, had just shown Marilyn the portfolio of photographer Milton Greene, and now she was waiting for "Color Photography's Wonder Boy" to arrive. When he did, Marilyn was surprised that Milt was so young. "But you're just a boy!" she exclaimed. Without hesitating, Greene replied, "And you're just a girl!" And that was the beginning of a professional relationship that would extend to many memorable portrait shoots as well as a partnership in a film production company. Their first sittings yielded artistic portraits, as well as several candids, including the one opposite, in which Marilyn takes a drink during a break. (Regarding the left foot: She had strained her ankle while filming River of No Return and was taking a few days off from filming for it to heal.) Right: On September 12, 1954, Marilyn and Joe arrive at the St. Regis hotel in New York City, heading for dinner at El Morocco restaurant with Milt and Amy Greene.

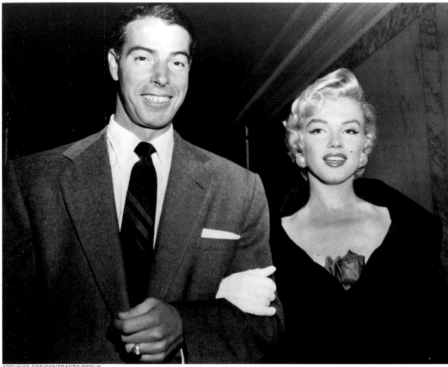

ARCHIVIO GBB/CONTRASTO/REDUX

Joe DiMaggio

ilton Greene's job, as he saw it, was to be "a photographer of beautiful women." Greene worked in the fashion industry before joining LIFE and developed a reputation for theatrical photo shoots. His stylist once recalled, "The way Milton would work, he would bring in the props, turn on the music—it was Stravinsky for Marlene [Dietrich]—turn off the phones and bring out the sherry." Greene photographed nearly everyone who was glamorous or fabulous in the mid-20th century—including men from Cary Grant to Norman Mailer—but he is best remembered for his work with Marilyn Monroe. Over four years in the mid-1950s, he photographed her during 52 sessions, and sometimes candidly, as here.

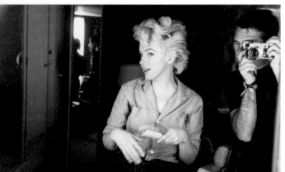

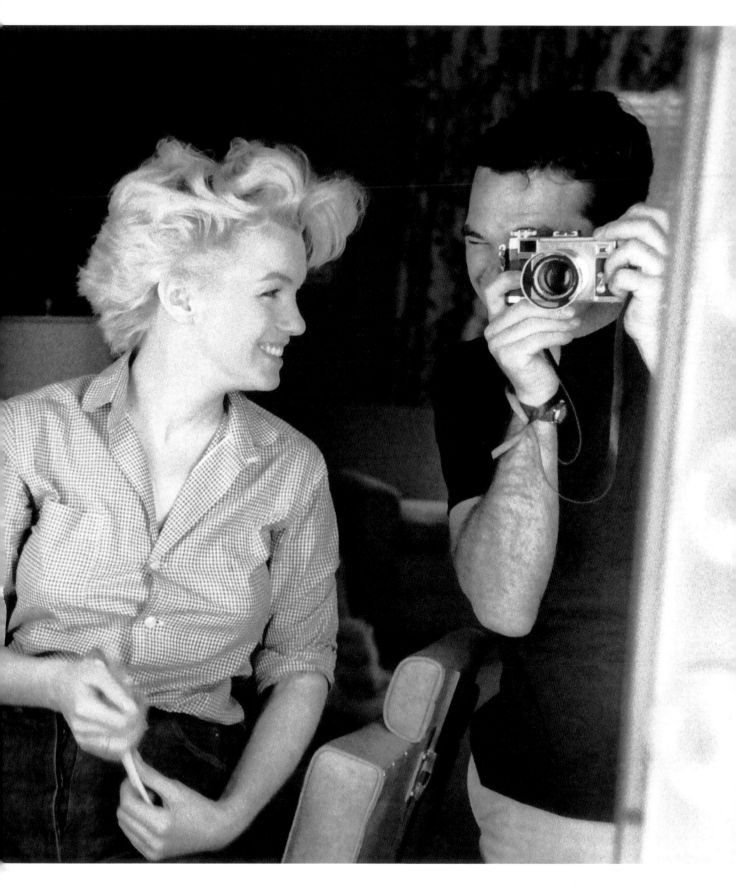

would not have been for the first time. And likely wasn't the last. In October, Monroe filed for divorce, alleging that DiMaggio was cold and indifferent (the polar opposite of red hot and mightily bothered). Soon afterward, she held a tearful press conference—with yet another suspicious bruise clearly visible on her forehead. All she could say was "I'm sorry." As she had before, she seemed to be—or to be playing—a lost little girl.

Though the marriage was finished, DiMaggio couldn't shake his obsession or stanch his jealousy. He hired a detective to follow Monroe, believing she was having an affair with her vocal coach, Hal Schaefer. (Schaefer later admitted this.) On the night of November 5, 1954, days after Monroe was granted the divorce, DiMaggio, acting on a tip from his detective, went with his pal Frank Sinatra and broke into a Beverly Hills apartment, expecting to surprise Monroe in Schaefer's arms and to do some damage. Instead of Monroe they found a sleeping woman named Florence Kotz. Monroe, it turned out, was in a different apartment nearby.

Despite the embarrassment occasioned by the so-called Wrong Door Raid, DiMaggio failed to put Monroe in his past. Remarkably, he was her date for the June 1, 1955, New York premiere of *The Seven Year Itch,* and even threw Marilyn an after-party to celebrate her 29th birthday at Toots Shor's restaurant. As in their married days, they argued—and she left early.

DiMaggio, crazy in love, was the only one of Monroe's lovers who never entirely freed himself of her—or, looked at another way, never abandoned her. He was there when no one else was, bringing her a Christmas tree when she was alone during the holidays; rescuing her from a mental ward where she'd been consigned by her therapist; returning to her side when her firing by Fox kindled hopes in him that, at last, with her career fading, there might be room for a real marriage. But it was not to be.

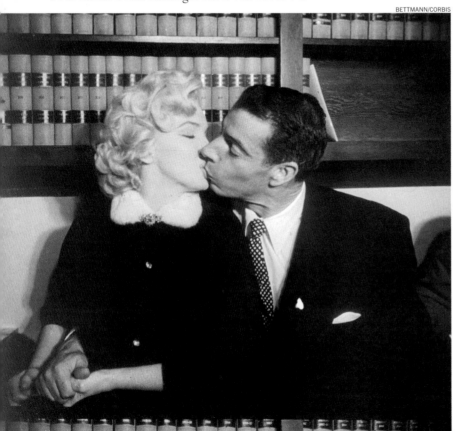

In late 1953, Fox ordered Monroe to report to the set of **The Girl in Pink Tights,** *just the kind of movie Monroe was loath to make at that time. She instead jetted off to meet DiMaggio in San Francisco at Christmas. When she failed to report yet again, after the studio had pushed back the start date to January, Fox suspended her. In the midst of all this, DiMaggio proposed marriage. Here's the absolutely irresistible original caption for the photograph at left, taken on January 14, 1954, when Joe and Marilyn wed in a three-minute ceremony at San Francisco City Hall: "Grace must be natural and Marilyn Monroe and Joe DiMaggio demonstrate that without rehearsal. This [photograph was] taken in the judge's chambers where they were married. You might call it the evolution of a wedding kiss. Bride and bridegroom move in on each other and purse their lips for the kiss. They do . . . meaningfully." Opposite: Same day, same situation, sans smooch.*

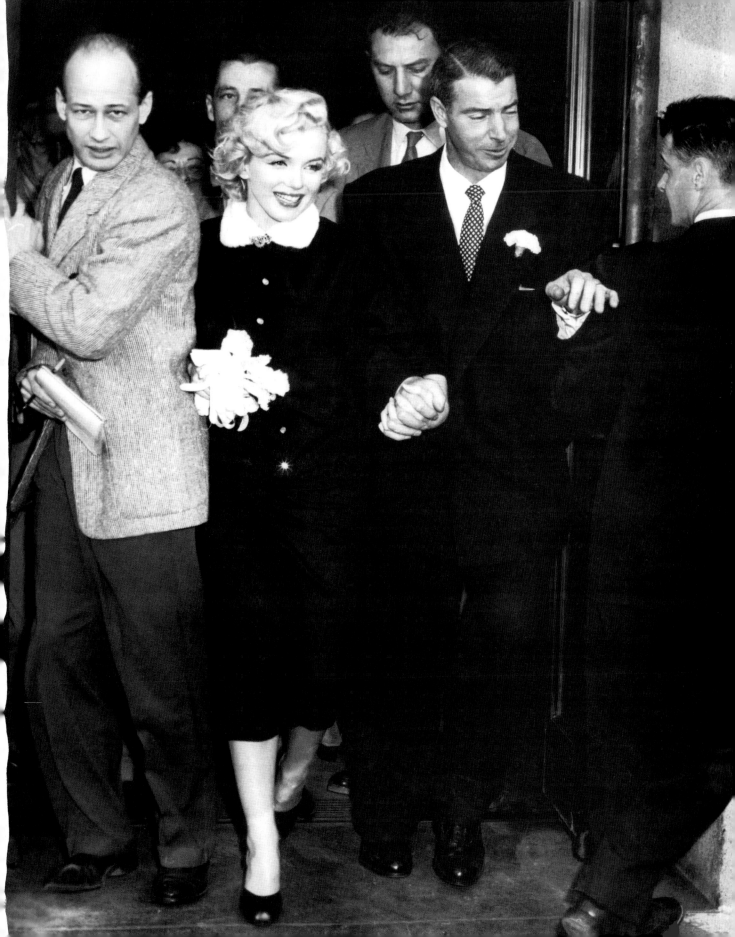

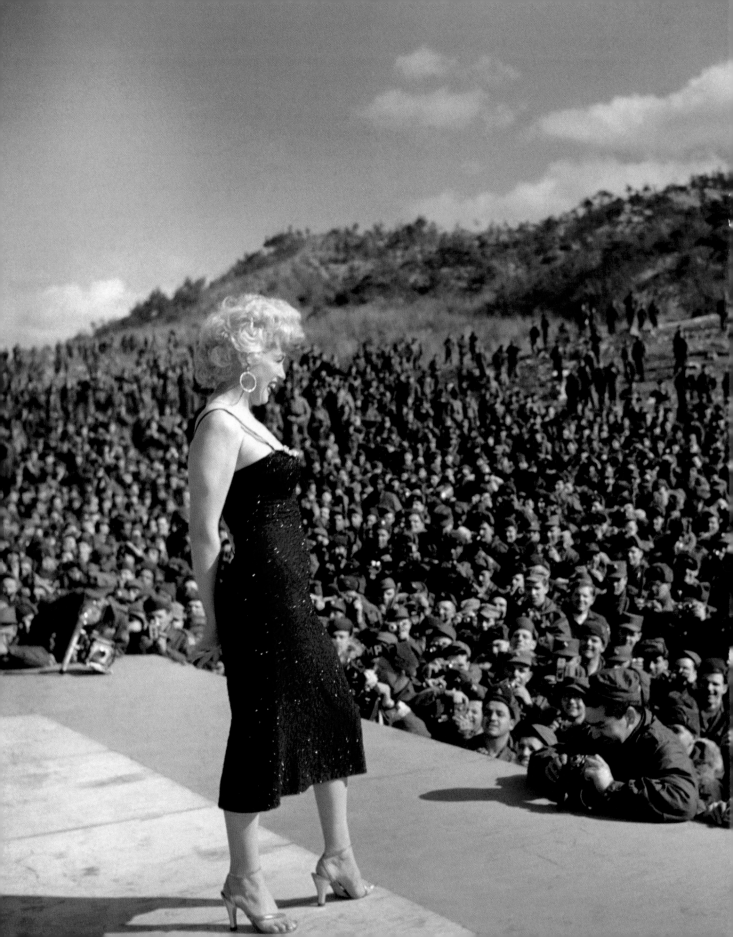

The newlyweds flew to Japan (below), where pandemonium attended their honeymoon as fans craned to see the baseball hero and, as one Japanese radio broadcaster put it, "the honorable buttocks-swinging actress." The wild attention, abroad as well as at home, coupled with the public's infatuation with his sexy wife, would very quickly prey upon the private, intensely jealous DiMaggio. We have noted this in our narrative already, but it bears repeating: Joe had, against any reasonable expectation, been hoping Marilyn would trade stardom for a settled-down life at home—a home that would be far from Hollywood. But her stardom was at its apex, while his was in eclipse, and DiMaggio's desires, it quickly became apparent, would not be fulfilled. While in Japan, Monroe was offered that opportunity to entertain tens of thousands of American servicemen during a four-day tour of South Korea, and she seized it. A bare-shouldered Monroe braved February temperatures to put on a series of honeymoon shows before roaring audiences of salivating GIs (left). "It was so wonderful, Joe," Monroe reported back excitedly. "You never heard such cheering." "Yes," her husband replied quietly, "I have."

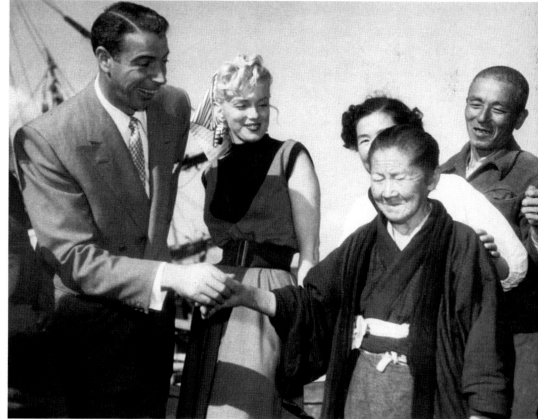

GEORGE ZENO COLLECTION

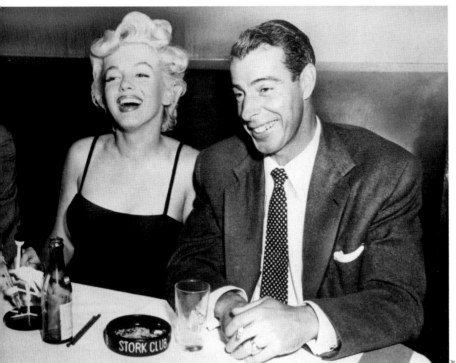

*T*he couple in New York City (above), eight months after their marriage. Right: Around the same time, Mrs. DiMaggio, shoeless and characteristically low-cut but otherwise not flagrantly flirtatious, offers thoughts about her husband to a sportswriter. Throughout her career, Monroe took particular pride in appealing to the everyman—being recognized by a dog walker or a garbage collector—and feeling like she gave their day a boost; all good. Good as well: Back in the U.S. after the weird honeymoon, Monroe at last returned to work at the studio. Fox had certainly heard her complaints, was renegotiating her contract and had agreed not to force Pink Tights on her if she instead took a role in the musical There's No Business Like Show Business. As a plum, she would be given a starring role in director Billy Wilder's The Seven Year Itch. That would lead to the scene on the pages immediately following—and indirectly to scenes on the pages following those.*

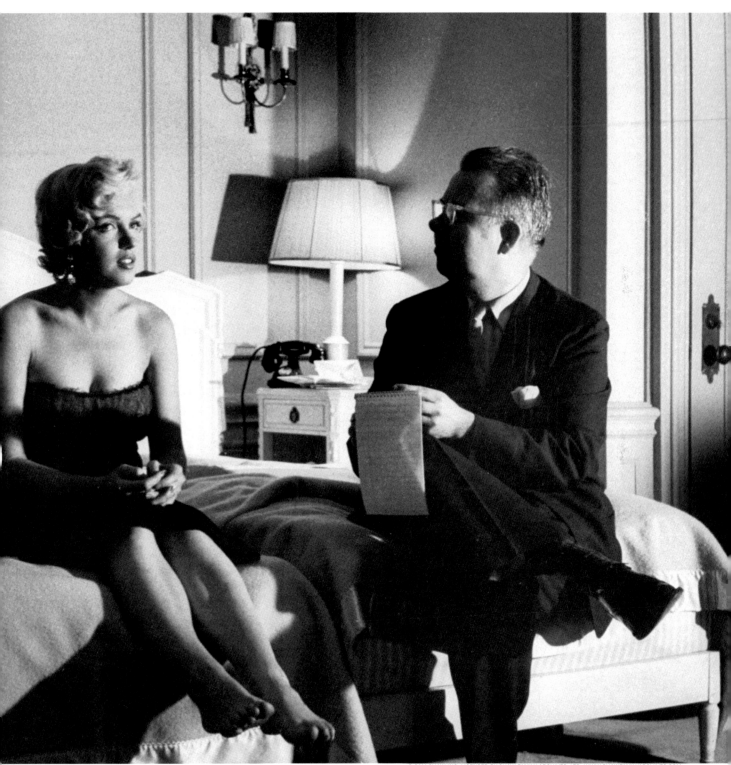

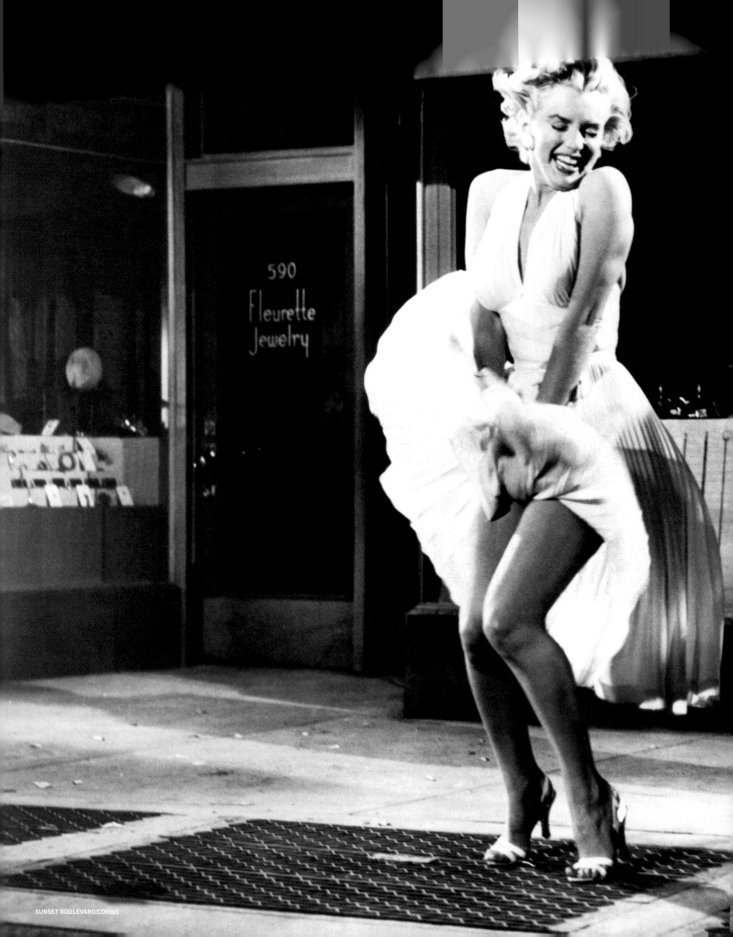

590
Fleurette
Jewelry

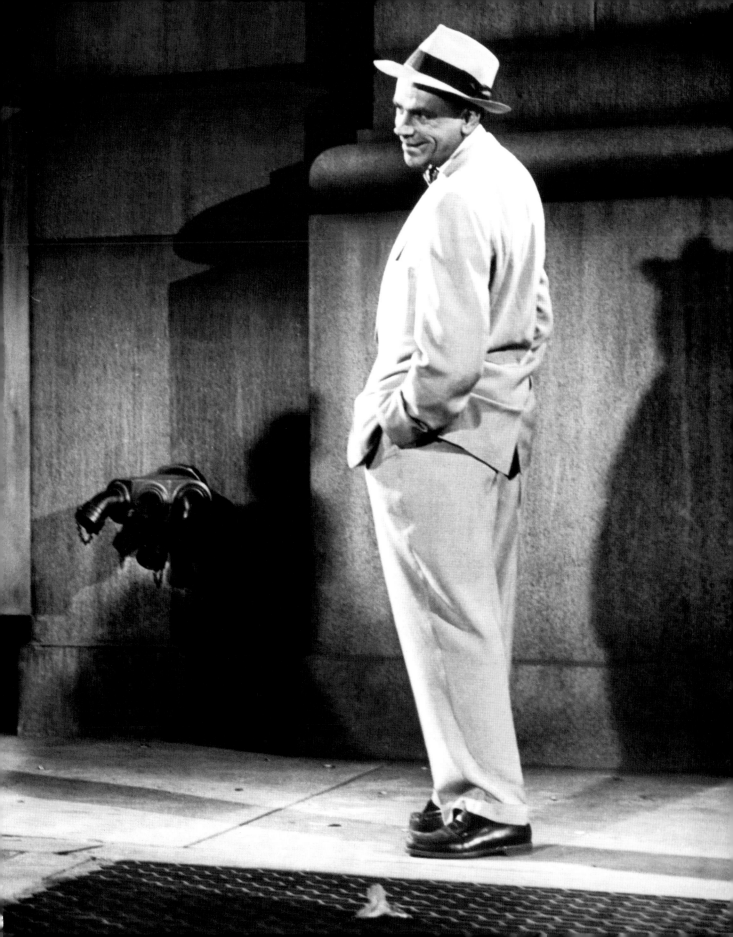

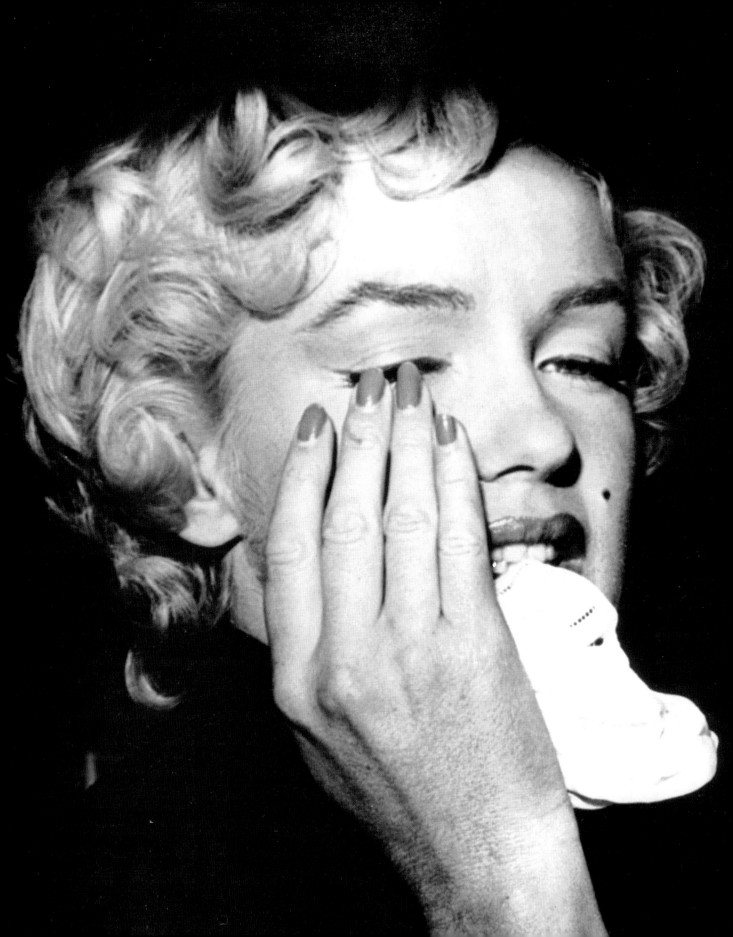

*A*lthough (and in many ways, because) Monroe's career was getting back on track, her marriage was quickly disintegrating. DiMaggio wasn't enjoying life in Beverly Hills; he would spend much of the day watching TV. He could be withdrawn and distant, and there were times, Monroe later said, when he would go days on end without speaking to her. He also continued to be greatly unnerved by Monroe's stardom, and—as we have indicated in our narrative—there is evidence that this strong former athlete was violent with her. The frayed knot of their marriage finally snapped in mid-September 1954 while Monroe was in New York City to shoot that famous *Seven* *Year Itch* scene, and wound up with, according to varying accounts, bruises on her shoulders or back the next day. Whether or not DiMaggio beat her that night, Monroe returned to Los Angeles and, within weeks, filed for divorce. At the proceedings she told the judge that the nine-month marriage had been "mostly one of coldness and indifference." And with that, it was ended. *Opposite: Monroe on the day she announced the divorce, October 6, 1954. Below: Same day, also in Beverly Hills, supported by attorney Jerry Giesler. Giesler said that Monroe had nothing further to offer except that her application for a divorce is based on a matter of conflicting careers, which of course was interesting because DiMaggio no longer had a career.*

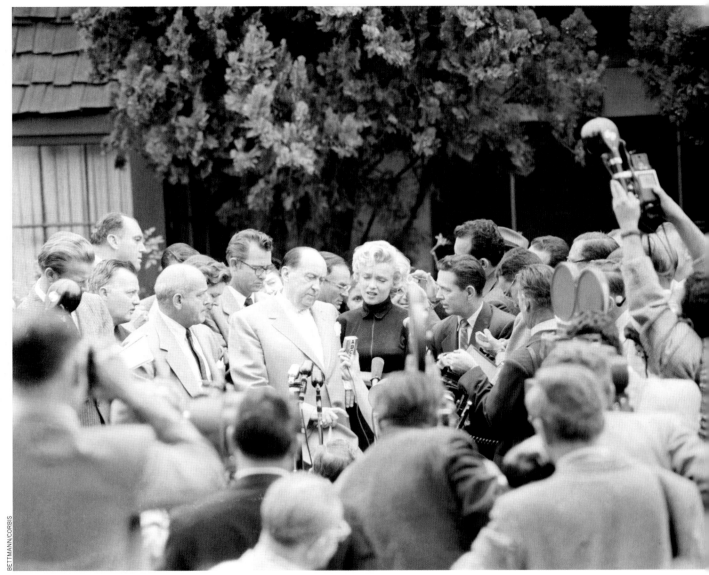

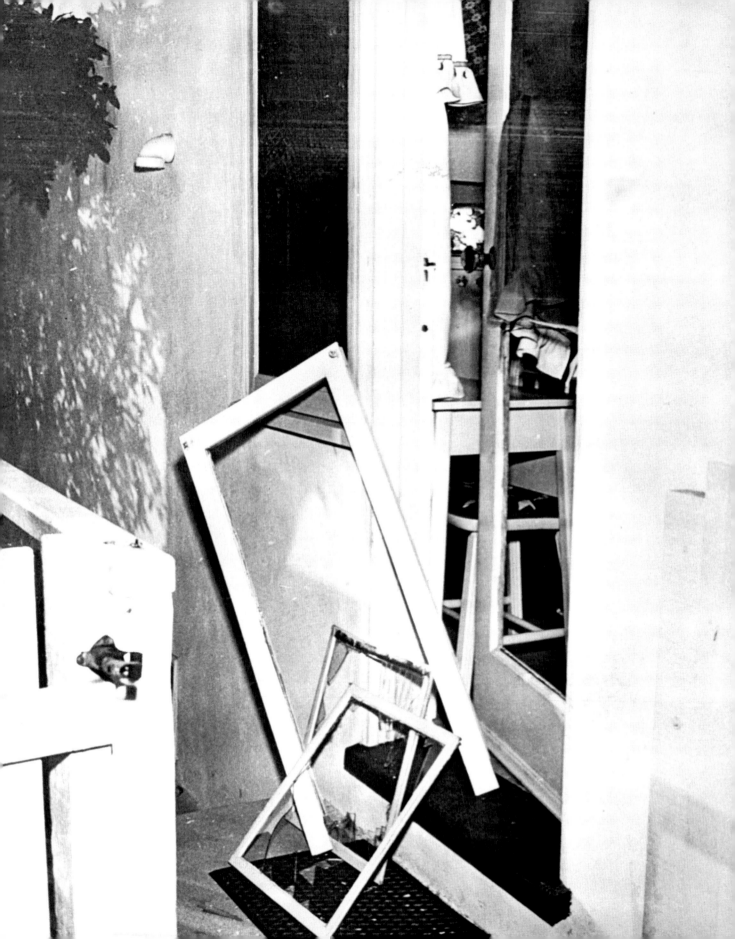

Opposite is a photograph of the "wrong door" that was part of a California State Senate probe in Los Angeles, which looked into whether Joe DiMaggio, former baseball star, entered the wrong apartment while attempting to catch his ex-wife with another man. He had been in the company of one Francis Albert Sinatra, below, a singer and friend, who is, in this picture, looking chagrined on his way to face a Los Angeles County Grand Jury investigating what happened. Sinatra has claimed he remained outside in a car during the escapade, a story contradicted by private detective Philip Irwin, who says Sinatra helped break down the door. The jury is looking into perjury charges. Florence Kotz will later recall a lot of commotion and, eventually, hearing one of the raiders call out, "We've got the wrong place!"—which was correct. And the raiders, which certainly included Sinatra and DiMaggio, then high-tailed it out of there.

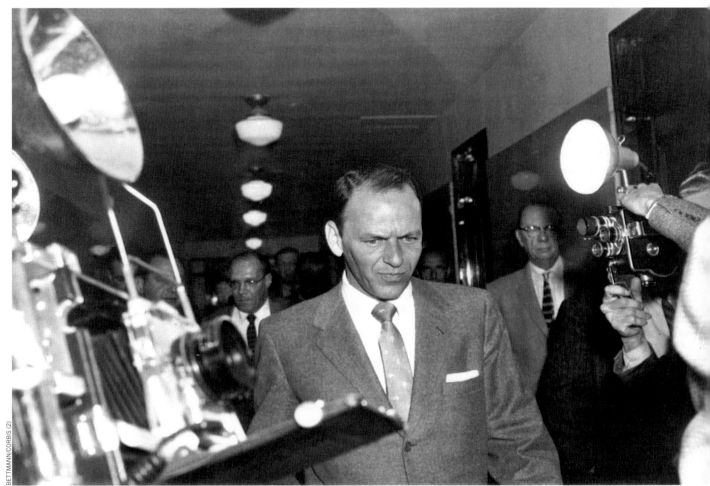

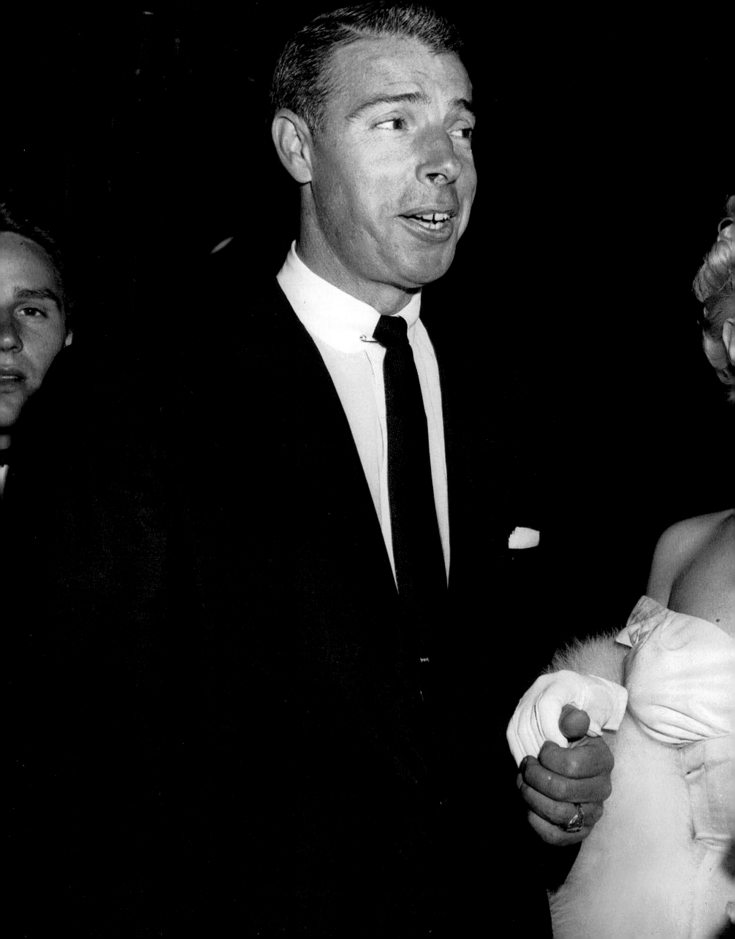

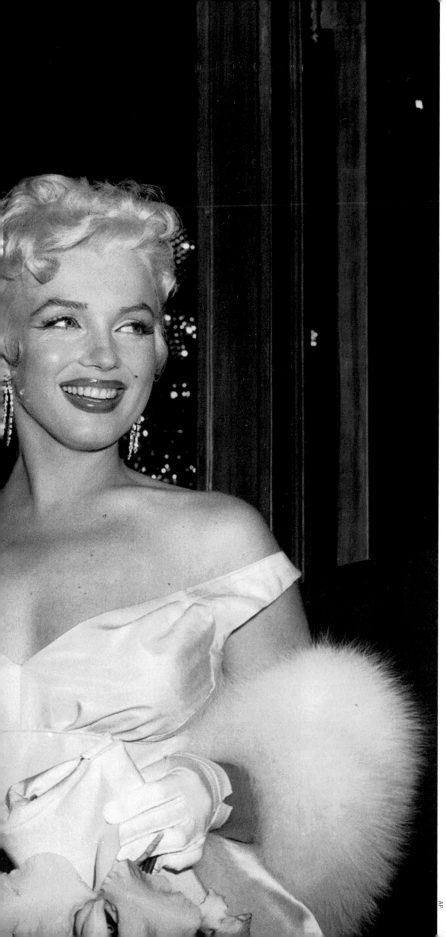

*B*elieve it or not, this is a picture of Joe and Marilyn on June 2, 1955, in New York City—in other words, more than half a year after they had split. They would never, ever get over one another, and that is a romantic fact to which we will return in these pages. For now: They were asunder, and although Joe did things as noble as throwing her a gala party in Gotham for **The Seven Year Itch**—he must have been a glutton for punishment—she was free to marry whomever. A first footnote on the dissolution of this famous relationship: The filming of the skirt-lifting scene for **The Seven Year Itch**, which finished things off, took advantage of a public location shoot to drum up interest and entice audiences. The footage of Marilyn's lower body that appears in the movie was shot later in a studio in Hollywood because the first footage was deemed too risqué. And a second footnote: The failure of their marriage deeply affected both DiMaggio and Monroe, and although the two were no longer legally bound to each other, they would remain emotionally tied. DiMaggio readily swooped in at a moment's notice whenever Monroe needed him. He would remain loyal to her in the last years of her brief life— and then, after her death.

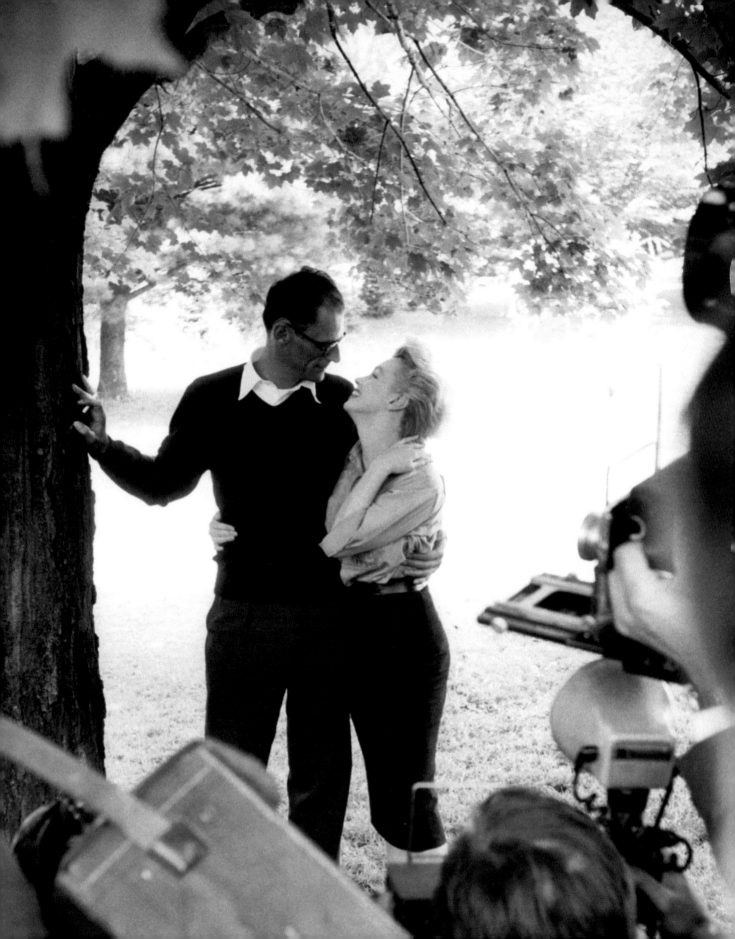

Arthur Miller

AT THE END OF 1954, EVEN AS SHE WAS DEALING WITH THE end of her marriage to Joe DiMaggio, Monroe—resenting the "dumb blonde" parts that Fox kept foisting on her—established her own film company, Marilyn Monroe Productions. Her friend photographer Milton Greene, who was supporting her financially and emotionally as she moved to New York after splitting from DiMaggio, became the company's vice president and de facto chief operating officer. Today Milt Greene's legacy as production chief is not as well known as is his legacy of beautiful portraits of Marilyn Monroe, many of which first appeared in LIFE, and one of which is seen opposite.

Some four years had passed since she had met Arthur Miller out West, but he hadn't been forgotten. "Occasionally I got a note from Marilyn that warmed my heart," Miller wrote of the interim. "She talked about hoping we could meet again . . . I wrote back a muddy, formal note saying that I wasn't the man who could make her life happen as I knew she imagined it might and that I wished her well. Still, there were parched evenings when I was on the verge of turning my steering wheel west and jamming the pedal to the floor." Now both of them were back East.

Monroe represented more than mere temptation for the playwright. She was also a muse; Miller, it has been conjectured, wrote both *The Crucible* and *A View from the Bridge* under her influence and inspiration. Both plays concern infidelity and love triangles. Such dramatic scenarios were made real after Monroe settled in Manhattan. On occasion, Miller and Monroe snuck around town, but mostly they carried on in her Waldorf Towers apartment, spending hours talking and just gazing down at the city below.

Perhaps unsurprisingly, the playwright painted their affair in dramatic terms befitting a Greek tragedy: "I was in a swift current. There was no stopping or handhold." Just as Monroe invested men with impossible attributes, so Miller invested Monroe with an almost mystical power. "She's kind of a lodestone that draws out of the male animal his essential qualities," he told *Time.* He idealized even her promiscuity, saying that each of her previous relationships had been "built on a thread of hope, however mistaken. [But] she has stopped wanting to throw herself away." Here's hoping.

During their courtship in the mid-1950s, Monroe was involved with many other men. Her dalliance with John F. Kennedy may have begun during this period, and she saw Henry Rosenfeld, a wealthy dress manufacturer she'd met in 1949. She claimed she had had an abortion, not her first, around this time. And she had an affair with Marlon Brando. According to his autobiography,

*B*ack in late December of 1950 in California, Monroe had met and been attracted to Arthur Miller, the playwright who, the previous year, had won a Pulitzer Prize for **Death of a Salesman**. In 1955, this time on the East Coast, they reunited and began an affair that would doom Miller's marriage. "She was a whirling light to me then," Miller would later write, "all paradox and enticing mystery, street-tough one moment, then lifted by a lyrical and poetic sensitivity that few retain past early adolescence." The photograph opposite was made in Roxbury, Connecticut, on June 30, 1956, by Arthur and Marilyn's friend Milton Greene. The property in Roxbury, which had been owned by Miller for years, was too small for the couple, and soon after the marriage the Millers bought a nearby farmhouse, which would be their principal home during their four and a half years of marriage.

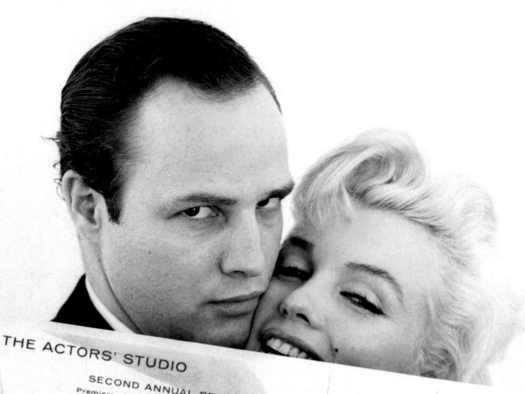

1995's *Songs My Mother Taught Me,* Brando first met Monroe after the war but bumped into her later at a party in New York. He kept in touch with her, and as he later wrote: "Finally one night I phoned her and said, 'I want to come over and see you right now, and if you can't give me a good reason why I shouldn't—maybe you just don't want me to—tell me now.'" She invited him over. So there was a fling with Brando.

Miller's divorce from his first wife was finalized on June 11, 1956. To secure it, the writer needed to stay in Nevada for six weeks, but he kept sneaking back to Los Angeles, where Monroe was making the film *Bus Stop.* Based on the acclaimed William Inge play, the film was the fruit of a new Fox contract that gave Monroe significantly more money and control. It marked her debut as a serious actress.

Meanwhile, Miller had been called to testify before the House Un-American Activities Committee (HUAC), the organization investigating allegedly subversive (read: communist) activities. While some of Miller's leftist friends—the playwright Clifford Odets and Elia Kazan among them—had "named names," others who refused to cooperate were blacklisted or jailed. After weeks of refusing to rat out his friends, Miller, luckily, went free (he was convicted, but the conviction was later overturned on appeal)—perhaps, some have suggested, because the committee did not want the negative publicity that would have surrounded the incarceration of Marilyn Monroe's paramour.

During his HUAC appearances, Miller proposed to Monroe in a public, oddly distant way. Laying groundwork for the star's later accusations of "coldness," the playwright told an interrogator that he wanted a passport to go to England to discuss a production of a play, adding: "I will be there with the woman who will then be my wife." When Monroe heard this, she called her friend, the poet Norman Rosten, saying: "Have you heard? He told the

arilyn and the Method: On the opposite page are Monroe and Marlon Brando (another of her lovers), helping to sell tickets to the film of **The Rose Tattoo,** *and at right, in December 1955, she is between drama coaches Paula and Lee Strasberg of the famous Actors Studio in New York City, where she and Brando trained in Method acting. By the end of 1954, it had become clear to Monroe that Hollywood, while making nice, was never going to cede much in the way of creative control. She found a loophole in her contract that under her interpretation freed her from Fox. She left L.A. for New York City, where she would spend a busy year in an earnest effort to improve her artistry and prove herself worthy of critical acclaim. Meanwhile, in early January 1955, she and Milton Greene announced the formation of Marilyn Monroe Productions. She was "tired of the same old sex roles," Monroe said at the unveiling of her new company. "People have scope, you know." The MMP gambit would, she hoped, allow her to leverage her box office performance with the studio; she figured, not incorrectly, that Fox needed her as much as she needed Fox. But more than stardom or money, what Monroe longed for was to be seen and respected as a serious actress. While MMP negotiated a new deal with Fox, she began acting studies with the Strasbergs, and at Lee's suggestion also began seeing a psychotherapist—as often as five times weekly—to enable her to tap into her thick catalog of emotions and memories. Strasberg considered such introspection the fuel of Method acting. Monroe came to revere Strasberg, and he, his wife and their children would become part of a small group that would wield tremendous influence over Monroe in the last years of her life.*

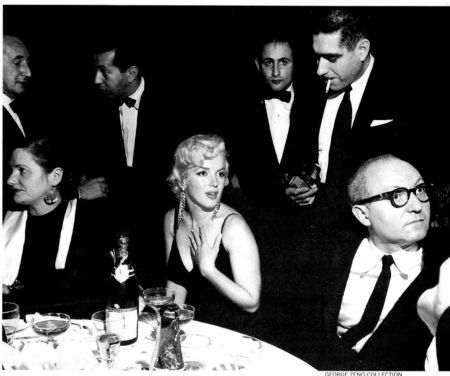

Arthur Miller

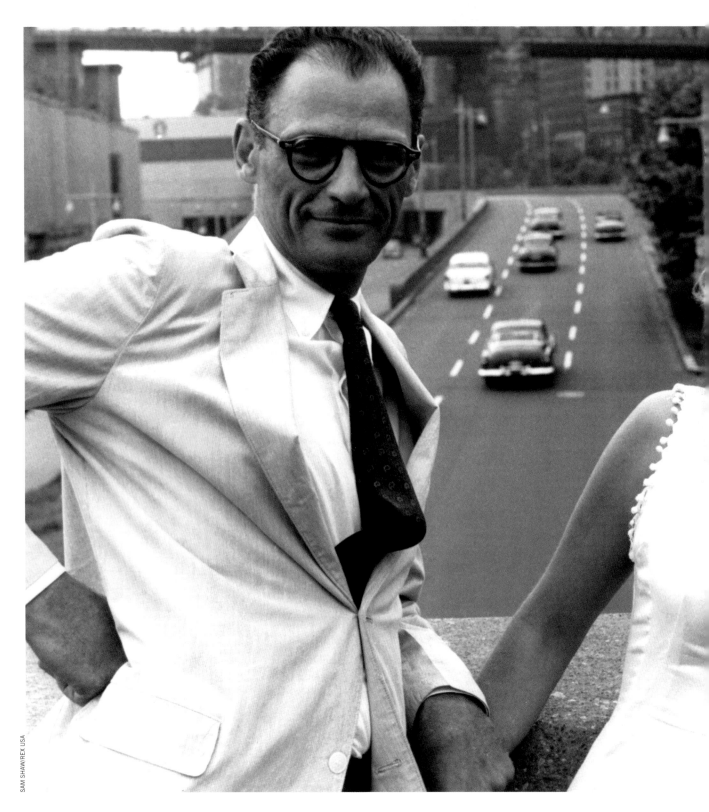

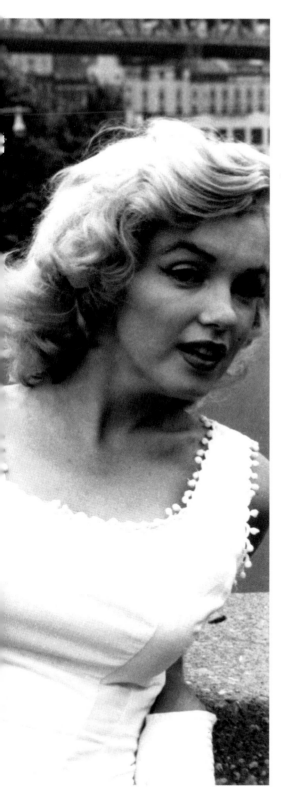

iller and Monroe in 1956 in New York City. After Miller divorced his wife in that year, he applied for a passport renewal so that he could travel to London; he planned to be there for production meetings for one of his plays, and to accompany Monroe as she worked on **The Prince** *and the* **Showgirl,** *the inaugural production of Monroe's new film company. But suddenly, Miller was summoned before the House Un-American Activities Committee, which said it was looking into passport fraud. For some time, Miller had been attracting the scrutiny of the committee, which had, as one focus, the goal of rooting out any communist infiltration of the entertainment industry. In 1953, Miller's heralded play* **The Crucible** *had made a metaphorical link between the work of HUAC and the Salem witch-hunt trials of America's colonial era. This complicated story continues in the caption on the pages immediately following.*

whole world he was marrying Marilyn Monroe—me! Can you believe it?"

As it happened, Miller had it right. He and Monroe were married in a civil service in White Plains, New York, on June 29, 1956. This was followed on July 1 by a traditional Jewish ceremony. (She had converted to Judaism for Miller.) For once, Monroe claimed, she was happy. As with every great love of her life, she felt that Miller was the long-lost father come to save her at last. She called him "Papa," writing in a journal that he was "the only person . . . that I trust as much as myself." Her need for support and approval was flattering to Miller, who seemed to relish the dual role of lover and surrogate daddy. But what initially appeals in romance often pales—even rankles—in everyday life.

Only weeks after their marriage, the couple traveled to London, where Monroe was filming *The Prince and the Showgirl* with Laurence Olivier. On the set, Miller had an uneasy indication that the woman he had married was not who he'd thought she was. He had endlessly sympathized with her frustrations with directors, studios and costars—but now he saw her erratic behavior firsthand. Her lateness and her increasing drug and alcohol dependency, even emotional unraveling, had little to do with evil outsiders and everything to do with her own troubled psyche.

She may also have been unfaithful to him. In his 1965 memoir, *Yes, I Can,* Sammy Davis Jr. claimed that Monroe had an affair with an unnamed man during the production. Donald Wolfe suggests that it may have been JFK, as Davis and the rest of the Rat Pack often covered for their favorite politician's indiscretions. While it is hard to gain consensus regarding the bare facts of Monroe's relationships with the Kennedy brothers Jack and Bobby, some think that Monroe was intimate with JFK throughout much of the 1950s.

The Miller marriage soured swiftly, though not just because of this. Arthur and Marilyn were still in England during filming in August when Monroe found her husband's diary lying open at Parkside House, the mansion outside London where they were staying. Reading it, she was shocked to discover that her husband was already questioning their relationship, worrying that she would sabotage his creative life—even calling her a "whore." To her acting coach, Paula Strasberg (as we know, Lee's wife), Monroe wailed: "Art once

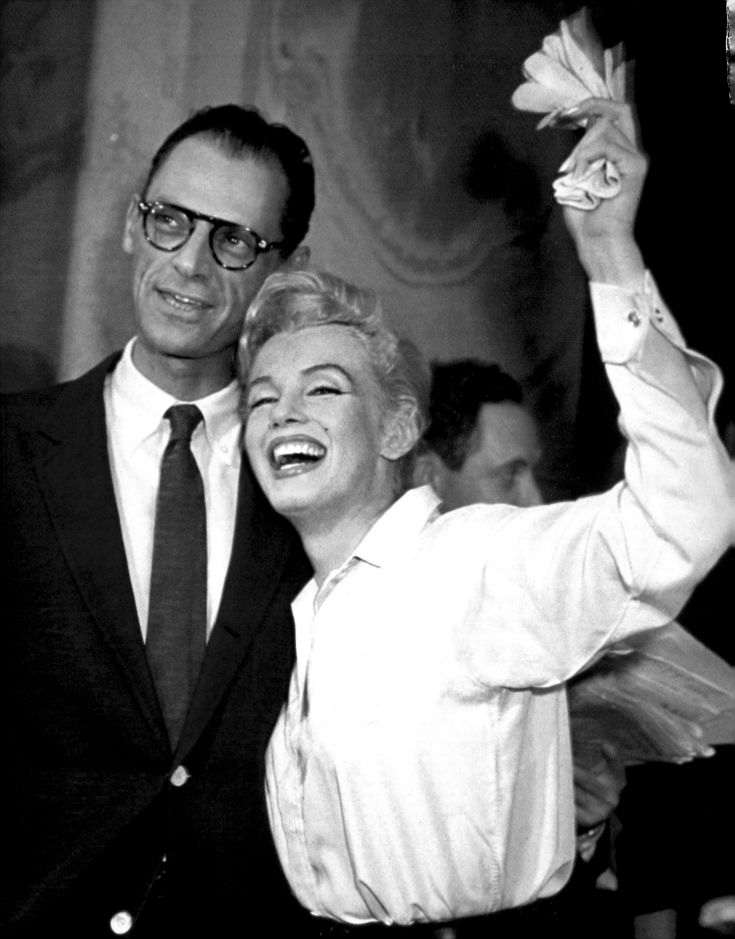

thought I was some kind of angel, but now he guessed he was wrong."

In *After the Fall,* Miller's autobiographical 1964 play, he sanitized the event, making himself more of a hero than he seems to have been. The Monroe character, Maggie, tells Miller's alter ego, Quentin, "You know when I wanted to die. When I read what you wrote, kiddo. Two months after we were married, kiddo. I was looking for a fountain pen to sign some autographs. And there's his desk . . . and there's his empty chair where he sits and thinks how to help people. And there's his handwriting. And there's some words, 'The only one I will ever love is my daughter. If I could only find an honorable way to die.' . . . That's what killed me, Judgey. Right?"

Still, the couple rallied. After filming wrapped on *The Prince and the Showgirl,* Miller and Monroe disappeared from public life, spending quiet time in Amagansett, Long Island, where they'd rented a cottage. They were trying to have a baby—it would have been her "crown with a thousand diamonds," Miller wrote. For a while, there was hope: In June 1957, Monroe discovered she was pregnant. But it was not to be. In August, she miscarried, the result of a tubular pregnancy. The child would have been a boy.

After the miscarriage, Miller rescued her from another overdose. "After she was revived, she would be extremely warm and affectionate to me because I had saved her," Miller wrote. Nevertheless, the misery continued. In December 1958, later in the day after the premiere of *Some Like It Hot,* Monroe miscarried again. This loss was followed by another depression—and yet another overdose. Miller was growing tired of trying to play the hero. There was all this drama, and on top of it, the cheating. Rosten writes that by this point Monroe had not been faithful to Miller "for some time."

In 1959, *Goddess* author Anthony Summers reports, the Bureau of Investigation of the Los Angeles District Attorney was looking into

*W*hether Miller's play The Crucible contributed to his being called to Washington has never been proved but always supposed. Miller, well aware of which way the wind was blowing, told the House Un-American Activities Committee in advance of the passport-fraud hearing that if he were pressed to name names of any associates who might have communist sympathies, he would refuse to do so. And so he entered the room. Monroe, warned that she was putting her popularity in jeopardy, nevertheless was steadfast in her support of Miller. As might have been expected, the committee demanded that Miller tell all that he knew—not about passports that might allow him to travel to London for the filming of his girlfriend's next movie, but about commies. He responded: "I could not use the name of another person and bring trouble on him." Miller would subsequently be cited and convicted for contempt of Congress, a ruling that would be reversed on appeal in 1958. But in the midst of the turmoil in Washington, before any citations had been handed down, Miller announced something that was even more consequential than communists were to a certain sector of America: He said that he planned to marry Marilyn Monroe. It was an unconventional proposal to say the least, but the lady said yes. They were wed, first in a civil ceremony on June 29, 1956, in White Plains, New York (opposite), and then again two days later in a Jewish ceremony before a small group of guests (right).

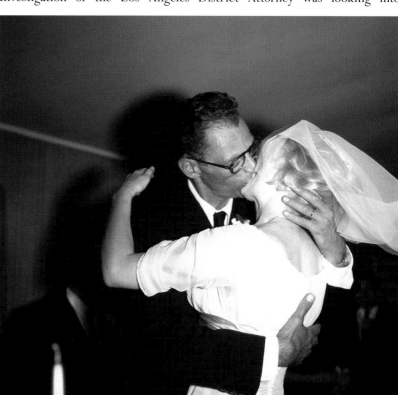

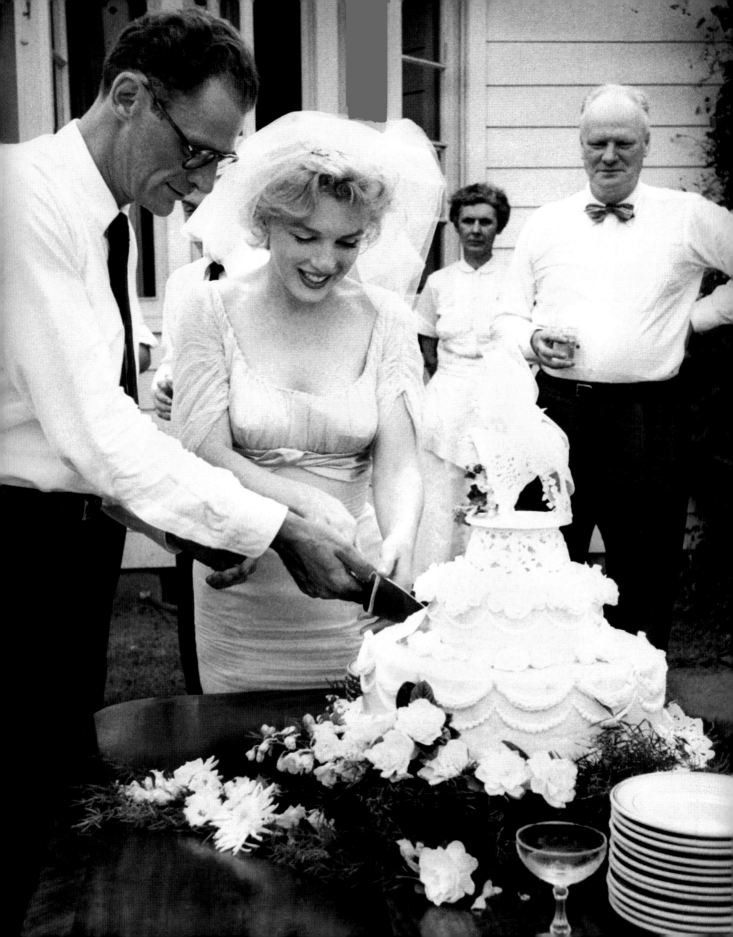

These photographs of the second wedding fete were taken by the bride and groom's good friend Milton Greene, and he certainly was a busy man during the week of the dual wedding ceremonies. His is by far the best record of the nuptials. Moreover, the weddings, especially this hastily arranged second celebration for 30 or so friends and family members, were to be super-secret, and Greene had to dash out and quietly purchase a suit for Miller from Milt's pal Jack Walker, who ran the Mannie Walker haberdashery store. The veil Marilyn wore during the second service, which was held at the home of Miller's literary agent Kay Brown in Westchester County, New York, belonged to Amy Greene, Milt's wife, so there were all sorts of "old, new, borrowed and blue" thanks to the Greenes. The veil had been dyed in tea to match Marilyn's sand-colored chiffon silk dress. Of course, once the couple cut the cake and Milt's fine photos inevitably circulated, the news was out. A headline in **Variety** *captured the prevailing view marvelously:* EGGHEAD WEDS HOURGLASS.

a blackmail racket allegedly spearheaded by the mobster Mickey Cohen. The bureau believed that Cohen was using handsome Italian boys to systematically seduce starlets. The sex would be taped or filmed, the evidence then used to extort money. (This, Summers suggests, may be what happened between Lana Turner and the abusive Johnny Stompanato, later murdered by Turner's daughter, Cheryl. But that's a whole other book.)

During the investigation, the bureau stumbled upon what seemed to be an affair between Monroe and a good-looking 28-year-old man named George Piscitelle. Staking out a restaurant on Sunset Boulevard, the investigators saw Monroe and Piscitelle emerging. "We followed their car over Coldwater Canyon to a motel on Van Nuys Boulevard," the investigator said. "We saw them go in . . . We didn't see them come out." The same investigator claims that he heard a "bedroom recording of Marilyn."

In January 1960, Monroe met Ralph Greenson, who would be her psychiatrist until the end of her life. He was, she felt, so helpful that she called him "a Jesus." But as Monroe rallied, Miller lost himself in her enveloping orbit. Although Monroe had called him "the boss," telling the press that their relationship was pupil-teacher, Miller now, he said, "had all but given up any hope of writing." (Truman Capote referred to their union as "Death of a Playwright.") Miller's only work of note during his late Monroe period was the screenplay for *The Misfits*—and that was written for Monroe. Like DiMaggio, he was locked in an obsessive love he could neither entirely escape nor entirely embrace. That problem would only deepen when his wife met Yves Montand, as we will see in our next chapter.

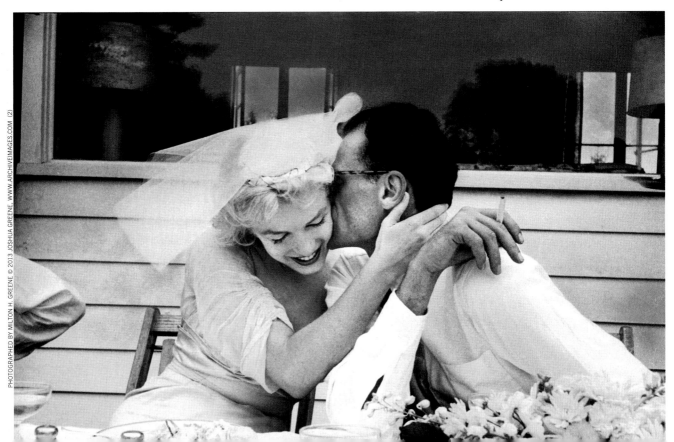

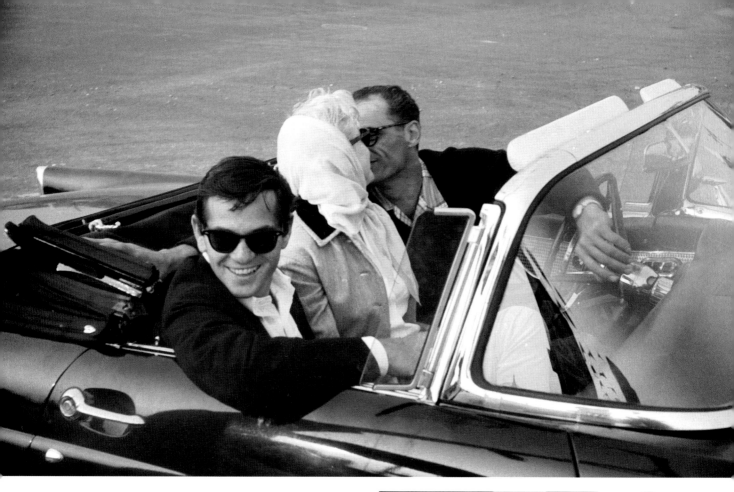

The two photographs on this page were taken in July 1956 when the blissful newlyweds and Milt Greene were traveling in a top-down T-bird back to Roxbury, where most of the rest of Monroe and Miller's wedded life would unfold. Everything was moving so very fast in the mid-summer days of '56 that Miller had to borrow his mother's ring for Monroe's finger at the second wedding ceremony. Miller had received that passport after all those congressional hearings, so before they knew it, they were off to London—for a first film shoot orchestrated by Marilyn and Milton's new venture, Marilyn Monroe Productions.

Arthur Miller

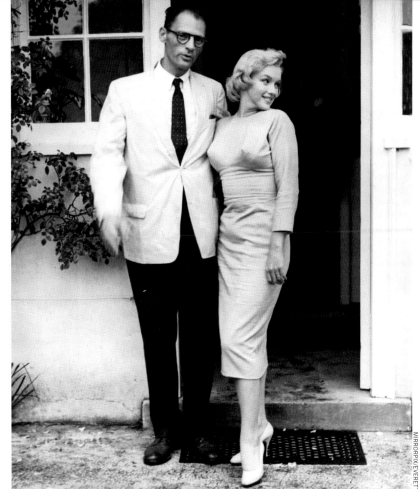

*I*t is still July 1956, but overnight the Millers are in a whole different land: here at Parkside House, Englefield Green, Surrey, England (right), and then, a couple of months on, at the Comedy Theatre in London (below, joined by Laurence Olivier). They are abroad while Marilyn films, opposite Olivier, The Prince and the Showgirl. "A brilliant comedienne," the future Sir Larry, who directed as well as acted in the movie, proclaims of his costar, "and therefore an extremely good actress." Maybe so, but not an easy one: She and her entourage make for a tense, unhappy set. Monroe has replaced drama coach Natasha Lytess with Paula Strasberg (the new tutor's ubiquity would factor into all Monroe's final movies, much to the dismay of a string of directors and producers). Olivier considers Strasberg a sycophant, a buttinsky and even a no-talent phony. There is also resentment that because Monroe is convinced her success hinges on the Method, Lee Strasberg has demanded for his wife an astronomical wage to work on the film. So Paula is not just in the way, as Olivier sees it, but is being royally rewarded. All these years later, this movie is not boldfaced on Monroe's résumé—nor on Olivier's.

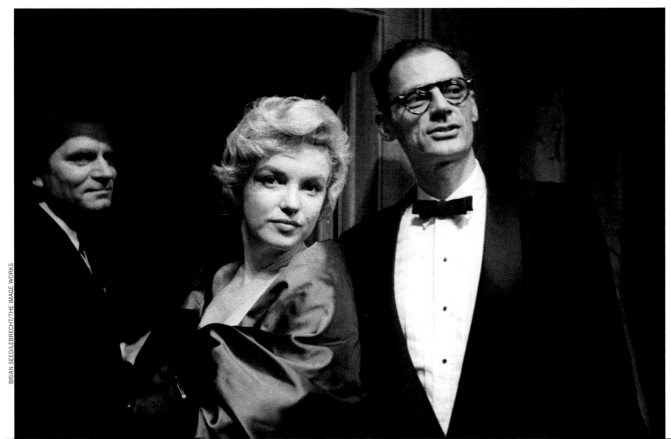

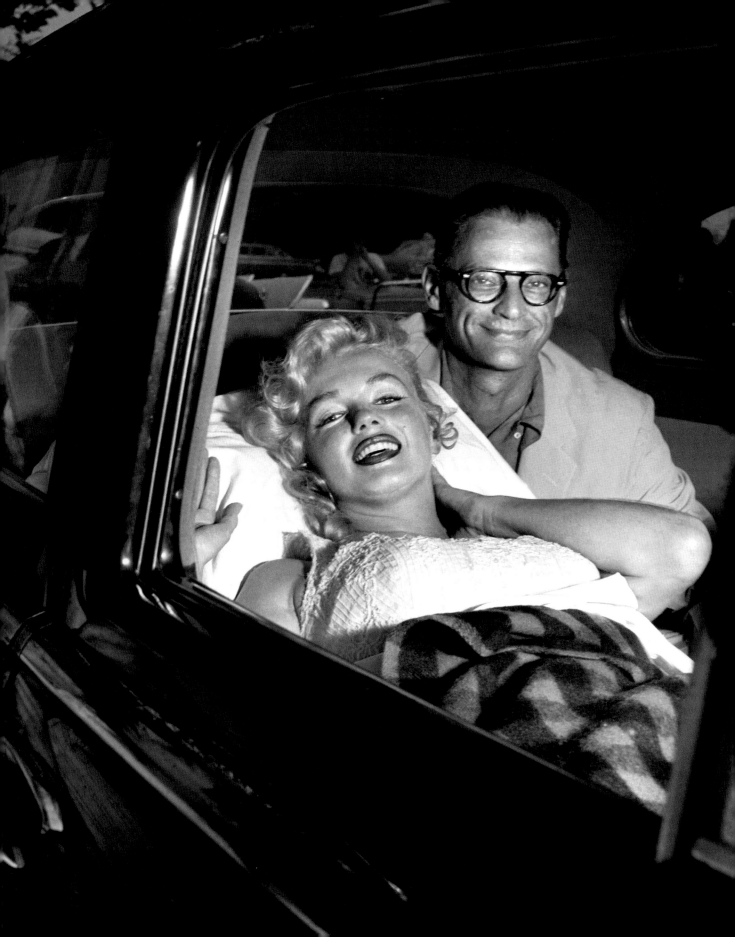

Below are Monroe and Miller at home in Roxbury, in 1957, and opposite: On August 10 of that year, leaving Doctors Hospital in New York City, where Marilyn has been released after losing her child, which had been expected in March '58. (They are in an ambulette—half-sedan, half-ambulance—headed for a continuation of their summer respite on Long Island.) After filming wrapped on The Prince and the Showgirl, *Monroe, who had plunged further into a dependence on pills for sleep and then, in turn, for alertness during the day, hoped that domesticity, time away from the movies and, most crucially, a baby might improve things. She and Miller tried to start a family, and Monroe did conceive, but it turned out to be an ectopic pregnancy, in which the fertilized egg grows outside the uterus. Such a condition is most serious and can lead to the death of the mother. The pregnancy was terminated soon after—that's a brave face here—and Monroe, who desperately wanted a child, was shattered. She was soon gaining weight, drinking too much and, according to some sources, taking copious amounts of sleeping pills. The pills would, reportedly, lead to a string of overdoses in the years to come. Biographer Barbara Leaming says that not long after this pregnancy—one of two with Arthur Miller—the playwright found his wife collapsed and breathing irregularly— a "sound [that] would become terrifyingly familiar" during the rest of their marriage.*

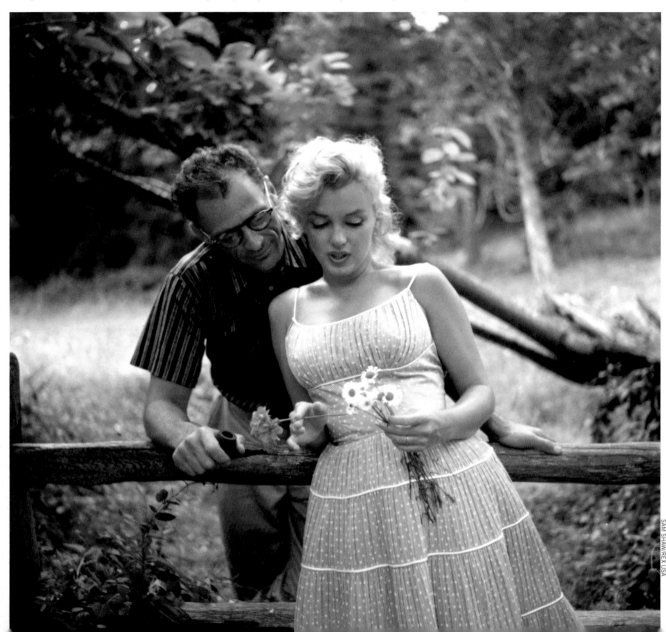

iller and Monroe had certainly seemed an odd couple from day one, but that notion does nothing to ameliorate the sadness that attends any final assessment of their marriage. From the very first, on that movie set in London, he behaved, according to some who were there, in a highly arrogant manner. He seemed to display little respect for his wife. Monroe was understandably hurt when she happened upon that entry in the playwright's open notebook that implied he was disappointed in her, that she wasn't the "angel" he had initially thought her to be. Later accounts, even unto the movie My Week with Marilyn, point to habitual infidelities during the Miller years. Yet there were tortured triumphs. In July 1958, with her husband's encouragement, Monroe returned to Hollywood, agreeing to play the part of Sugar Kane Kowalczyk in director Billy Wilder's Some Like It Hot (opposite, Wilder, Monroe and costar Tony Curtis, with whom she had yet another affair, at least according to Curtis; right, Marilyn and Tony again, between takes). Monroe's behavior on the production of this movie made what had transpired during The Prince and the Showgirl shoot look like a pleasant stroll through Kensington Gardens. She was routinely late, unsure of her lines and insistent on numerous retakes of the simplest scenes. The merest slipup could cause tears, which meant her makeup needed to be retouched. From a thermos, according to biographer Barbara Leaming, she sipped vermouth throughout the day. "We were in mid-flight," Wilder is quoted as saying in Anthony Summers's Goddess, "and there was a nut on the plane." Wilder said elsewhere that instead of the Actors Studio, "she should have gone to a train-engineer's school . . . to learn something about arriving on schedule." He elaborated for biographer Donald Spoto: "To tell the truth, she was impossible—not just difficult . . . There were days I could have strangled her, but there were wonderful days, too, when we all knew she was brilliant . . . Yes, the final product was worth it, but at the time we were never convinced there would be a final product." That product, which is regarded as a comedy classic today, was a smash hit, garnering six Oscar nominations. Monroe won a Golden Globe for her performance.

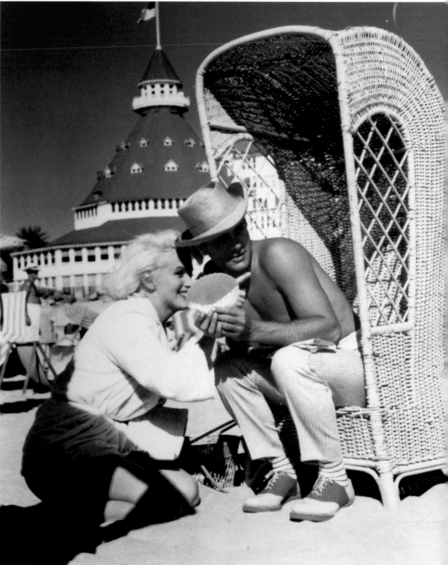

UNITED ARTISTS/PHOTOFEST

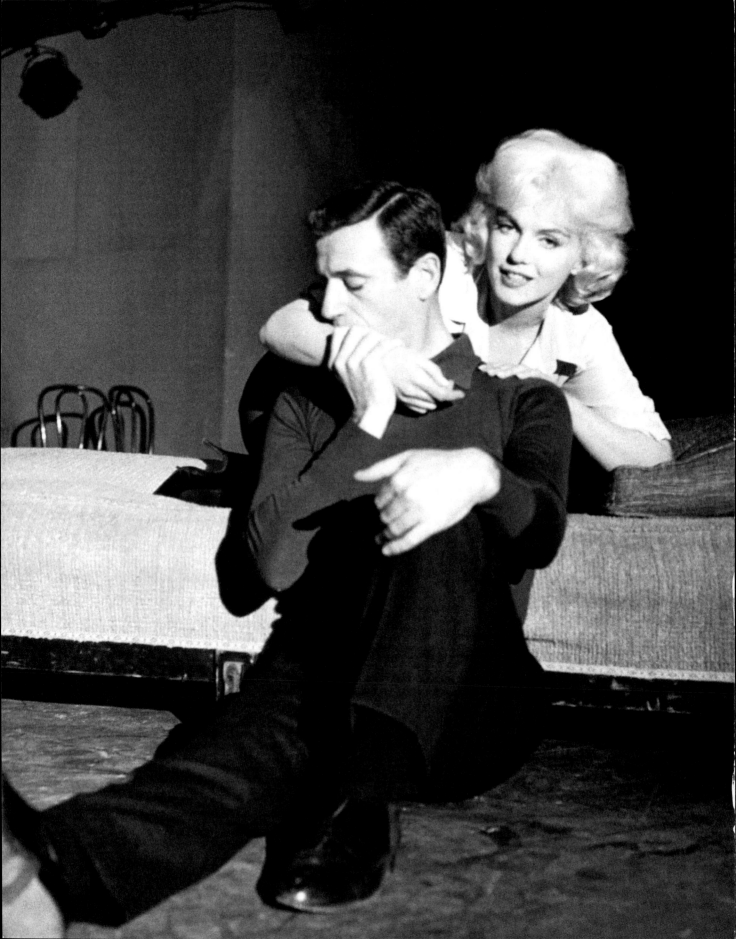

Yves Montand

THE HANDSOME ITALIAN-BORN FRENCH ACTOR AND SINGER
had been an early entrant on a list of desirable men that Monroe had compiled with her roommate Shelley Winters. Aside from Marlon Brando and Monroe's own husband, Arthur Miller, Montand was—Monroe said—the most attractive man that she had ever seen.

But he was hardly the first choice to star opposite Marilyn in the 1960 film *Let's Make Love.* Just about all of the male Hollywood stalwarts had turned the part down, perhaps because of Monroe's growing reputation for being difficult. (Gregory Peck withdrew at the last minute when Arthur Miller started rewriting the script.)

Montand arrived in Los Angeles with his wife, Simone Signoret, in January 1960, staying next to the Millers in a Beverly Hills Hotel bungalow. The couples became friendly, but—like many before him—Montand became exasperated by Monroe's lack of professionalism. He even sent her a scolding note. "I'm not the enemy," he wrote. "I'm your pal. And capricious little girls have never amused me." Perhaps as a result, she started behaving better on set.

Off-set, it was another story: Monroe and Montand began an affair under their spouses' noses. In his 1992 memoir, *You See, I Haven't Forgotten,* Montand tells of an evening when, saying goodnight to Monroe in her bungalow (Miller was in Ireland doing preproduction on *The Misfits*), he kissed her chastely goodnight—and she kissed him back with something more than chastity on her mind. Montand wondered "what was happening to me. I didn't wonder for long."

The name of the 1960 film, which would be Monroe's last musical comedy, was **Let's Make Love,** *and if the married suave French actor and married blonde American actress needed any further prodding, the title alone was sufficient. It is not a well-remembered film, for every good reason, though it seemed to have a lot going for it as it came together. First, the great George Cukor (*The Philadelphia Story, My Fair Lady *and so much else) was to direct, and he was known to be a wizard when guiding actresses. The screenwriter Norman Krasna had hoped for Cyd Charisse as his female lead, but Monroe, who was coming off the successes of* **Bus Stop** *and* **Some Like It Hot,** *was fine with Cukor. She was perceived as a problem by prospective costars James Stewart and Cary Grant, who were wary of on-set dramas, and Gregory Peck was signed. When Arthur Miller rewrote the script to his wife's advantage (can you believe the same man took pen to paper on* **Death of a Salesman** *and* **Let's Make Love?***), Peck bowed out and Yves Montand entered, stage left. As we see here and on the next two pages, there are several extraordinary photographs of Montand, Monroe, Miller and Simone Signoret (Montand's wife, seen in the photograph at right with the others during a press conference) socializing during the filming, even as they were socializing in other ways beyond the camera's gaze.*

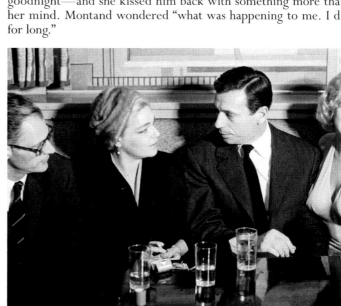

Characteristically, Monroe invested this dalliance with more significance than it was worth. "At any period of her life," Miller wrote, "the oncoming stranger was vitally important. He or she was invested with immense promise, which of course was smashed when this person was discovered to be human." But the affair didn't last long enough for even disillusionment. "Nothing will break up my marriage," Montand proclaimed. For her part, Signoret took the high road, saying that Monroe's adventure with her husband merely proved that Monroe had good taste. Returning to France after filming, Montand and Signoret found *Paris Match* headlines proclaiming that the Montands had survived "Hurricane Marilyn."

But had Marilyn survived Montand? The star was slipping deeper into alcohol and drug abuse. Her third marriage had all but ended, yet she was still yoked to Miller: She had committed to play Roslyn in *The Misfits.* Though Miller called the script a "gift," he had been paid $250,000 for it by his wife's Marilyn Monroe Productions, and, in a sign of the worsening relationship, the star had come to see it as a reflection of her husband's opportunism and greed. Worse, some of it was, Monroe felt, "dreck." Miller had based Roslyn on Monroe, but she felt misrepresented, misunderstood and misused.

On July 13, 1960, in Los Angeles, John F. Kennedy won the nomination as the Democratic candidate for President, famously telling the country that "we stand today on the edge of a New Frontier." After the convention, Kennedy's brother-in-law Peter Lawford (he was married to JFK's sister Pat) threw the candidate a typically raucous party. Lawford was a weak soul, an addict who clung to the coattails of alpha males—namely, Frank Sinatra and Kennedy. Hard as it is to imagine now, Lawford had once been more of a public figure than JFK. He had been successful as both a child actor and as a leading man, but now his biggest role was as "brother-in-Lawford"—procurer for rich and powerful friends. He offered not just booze and dope but the prettiest gals from all over Southern California at his fabled Santa Monica beach house.

The former Louis B. Mayer residence on Palisades Beach Road would later become known as the White House West because JFK used it as his home base in L.A. Many wild parties were held there—and the post-nomination bash was no exception. Marilyn was seen that night by a number of people, including a bartender borrowed from Romanoff's. The celebration lasted well into the wee hours, with plenty of nude prostitutes. The New Frontier, indeed. This was crazy, reckless behavior.

Though both Jack Kennedy and, albeit less so, Marilyn Monroe had a lot to lose, the two continued to see each other. She would sometimes meet him wearing a disguise—a brunette wig and glasses—and her calls were put through to Kennedy with the code name "Mrs. Green."

In July 1960, *The Misfits* started filming in Reno, Nevada. With this film—her last—Monroe had come full circle: It was directed by John Huston, who had also made *The Asphalt Jungle,* her first major production. And it starred her childhood father surrogate—her original father surrogate—Clark Gable. Ah, but despite this fulfillment of fantasy, Monroe was a druggy, emotional mess on the set and overdosed again in her hotel room on August 26. This time, she was rescued by Paula Strasberg.

She had friends, even in the worst of times.

*D*omestic bliss, Beverly Hills style (in Montand's hotel apartment there), as enacted in 1960. Signoret and Monroe really did cook together (so did Montand and Monroe, in the sense of turning up the heat, and perhaps Miller and Signoret as well). Finally, with the film wrapped, Signoret said, Enough of this nonsense, let's go home. Which she and Montand did—leaving the world with nothing but these priceless, entirely incomprehensible, intimate photographs. The French stars' marriage lasted 34 years, until Signoret's death in 1985, and when Montand died at age 70, he was buried in a plot in Paris's Père Lachaise Cemetery and now lies, forevermore, right next to Signoret. L'amour. Toujours l'amour.

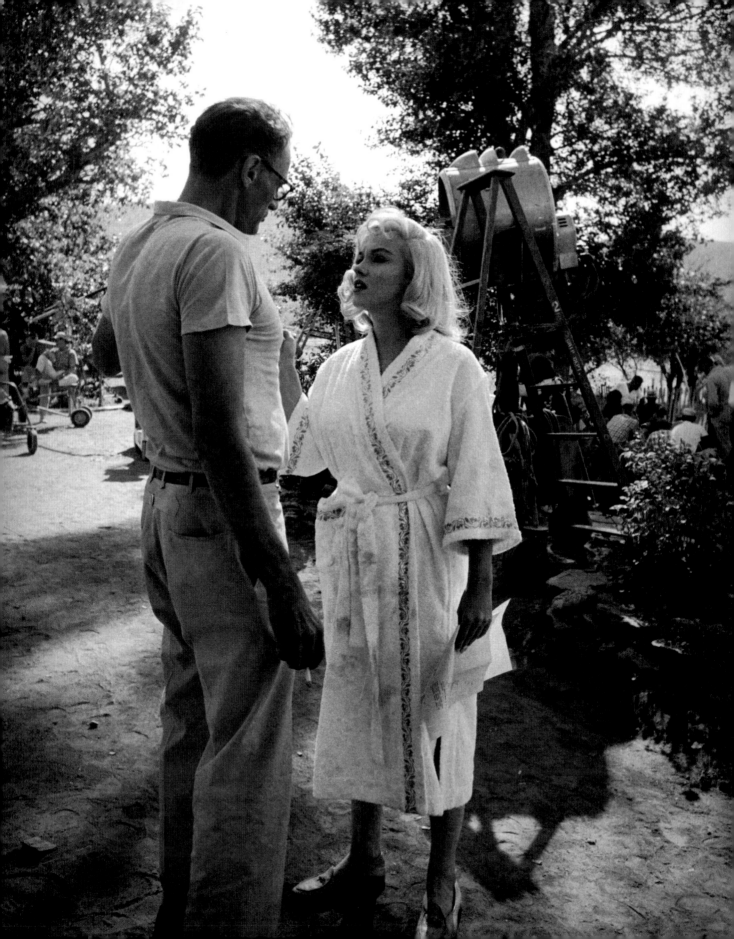

Yves Montand

In a book entitled The Loves of Marilyn, *we editors necessarily have, at the end of the day, favorite stories among the many choice ones. On these pages, we share our two toppers, only one of which has accompanying photographs. In first place: that Monroe may have had an affair with Albert Einstein (her onetime roommate, the actress Shelley Winters, suggested this in her autobiography). Runner-up: that, as we have briefly mentioned earlier, Marilyn thought Clark Gable was her father. Young Norma Jeane's mother had a picture of a man she had once dated on her wall, or so goes the story. "He had a thin moustache like Clark Gable," Monroe later remembered. "I asked my mother what his name was. She wouldn't answer." In 1935, the girl went to see a movie called* China Seas, *starring Gable and Jean Harlow, and from the moment she exited the theater Gable was "the man I thought was my father." They would eventually work together, as we see here, on a movie based on a screenplay Arthur Miller had been working on for a few years—a script that at first he had intended as a kind of homage, a love letter, to Monroe. She was never enthusiastic about the depressed divorcée role Miller had written for he; she found it wholly too close to home. But the playwright was dogged in his determination to get the film made. The movie was* The Misfits, *and it would be the last Monroe would ever complete. The heat in the Nevada desert, reflected in these pictures featuring Monroe, Miller, Gable and acting coach Paula Strasberg, was oppressive in the summer and fall of 1960, when the film was shot, and everyone was on edge. Miller was constantly revising his screenplay, which didn't help matters, and constantly feuding with his wife. As for the director, John Huston: His penchant for drinking and all-night gambling left him so debilitated at times that he would fall asleep in his chair. Monroe, of course, certainly merits her share of the blame for the generally miserable atmosphere: Her consumption of addictive barbiturates, which she sometimes pricked with a pin to hasten their effect, was on the rise, and she may have been taking other drugs as well. Gable, who liked her and tried to support her, reportedly said after the sets had been struck, "Christ, I'm glad this picture is finished. She damn near gave me a heart attack." In early November 1960, shortly after leaving Nevada, Monroe and Miller announced they were divorcing. Barely a week later, Gable died of a coronary at 59; there was speculation that the stresses of making* The Misfits *were a contributing factor. Monroe's depression was only made worse now by an overwhelming sense of guilt.*

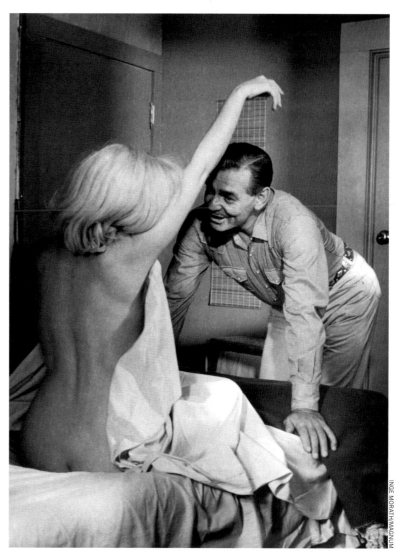

INGE MORATH/MAGNUM

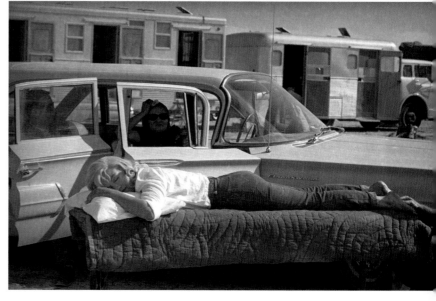

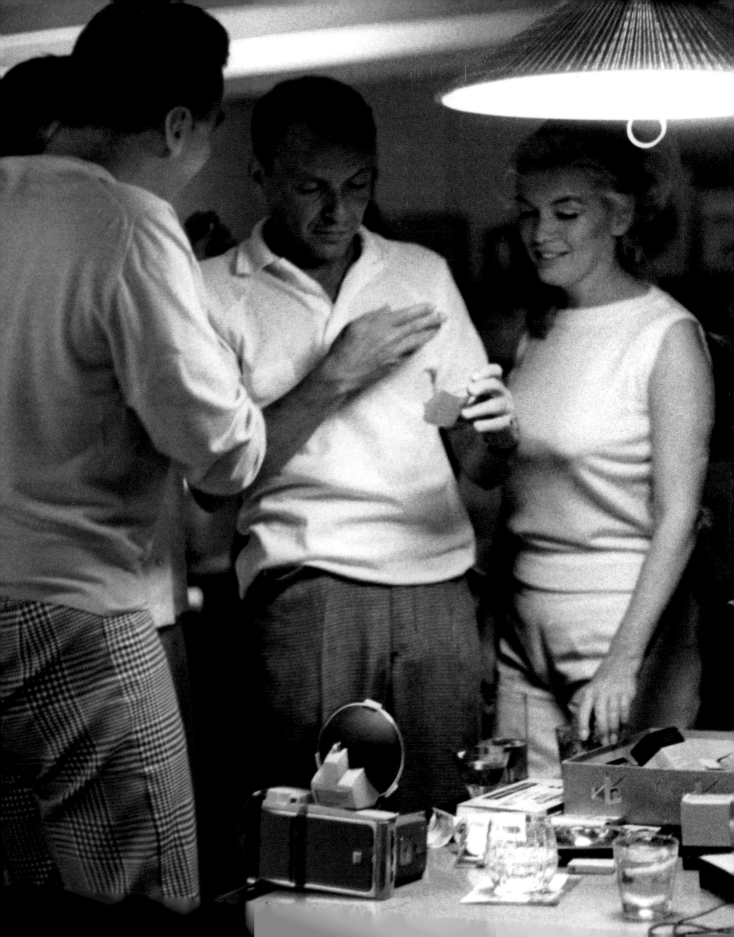

Frank Sinatra

"MISS MONROE REMINDS ME OF A SAINTLY YOUNG GIRL
I went to high school with, who later became a nun," Ol' Blue Eyes jokingly told a reporter. Ha, ha. Frank Sinatra was not a funny guy—it drove him crazy how inept he was onstage with any kind of bon mot—and this is yet more proof. Sinatra's relationship with Monroe was anything but holy. Indeed, the singer exerted a sinister influence on Monroe. In a letter sent around this time, the early 1960s, Monroe's psychiatrist referred to "destructive people, who will engage in some sort of sadomasochistic relationship with her." If Sinatra wasn't on his mind—and he probably was—he should have been.

Sinatra had charm—and money—to burn, and following Monroe's separation from Miller, she sought refuge with him, an "old friend." He was extraordinarily generous when he wanted to be, and gave her gifts of emerald earrings worth $35,000 and a white Maltese terrier that Monroe dubbed Maf, short for—yes—Mafia, a nod to this latest boyfriend's underworld connections. Those connections would become part of the most disturbing, lurid episodes in the star's life to come, but more on that soon.

On January 20, 1961, John Fitzgerald Kennedy was inaugurated as the 35th President of the United States, having won by a narrow margin. That same day, Monroe obtained her Mexican divorce from Miller. It had been her press agent Pat Newcomb's idea: With JFK dominating the news, Monroe's sad story wouldn't be noticed. So as Kennedy stood in Washington, D.C., saying "the torch has been passed to a new generation," Monroe traveled to dusty Juárez. Her nearly five-year marriage to Miller—the longest of her life—was over.

This trajectory has been manifested in lots of love lives: nice, safe partners at the outset (guys like Jimmie Dougherty) and then a general progress through more complicated characters, to the truly dangerous (guys like Frank Sinatra, not to mention the Kennedys). Sinatra was married to Ava Gardner when he first met Monroe through his friend (her husband) Joe DiMaggio in 1954, so if sparks were to fly, they didn't right then. As we have recounted, Sinatra was a participant in the Wrong Door Raid instigated by DiMaggio after his marriage to Monroe had unraveled and DiMaggio was wondering about whether Hal Schaefer was her lover. Now, in 1961, Monroe was on the far side of her marriage to Arthur Miller, and Sinatra, for his part, was characteristically available for a fling. He is seen with Monroe and Peter Lawford, who would become a player in many of the suicide/murder theories after Monroe's death, in the photograph opposite, and, right, at a party at the Cal-Neva Lodge, which he co-owned, attended by club manager Bert "Wingy" Grober. If some of Sinatra's liaisons lasted only days or even minutes, this one endured for at least several weeks. Monroe, in fact, talked to friends about the possibility of marrying Frank. But that sensational outcome was not to be, and he quickly took up with the actress and dancer Juliet Prowse.

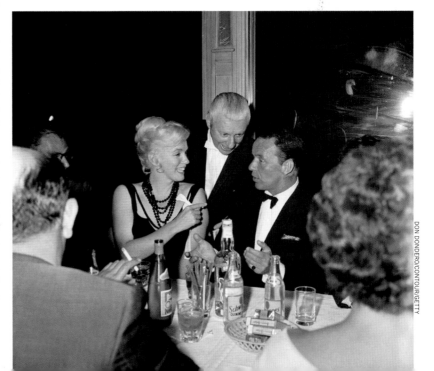

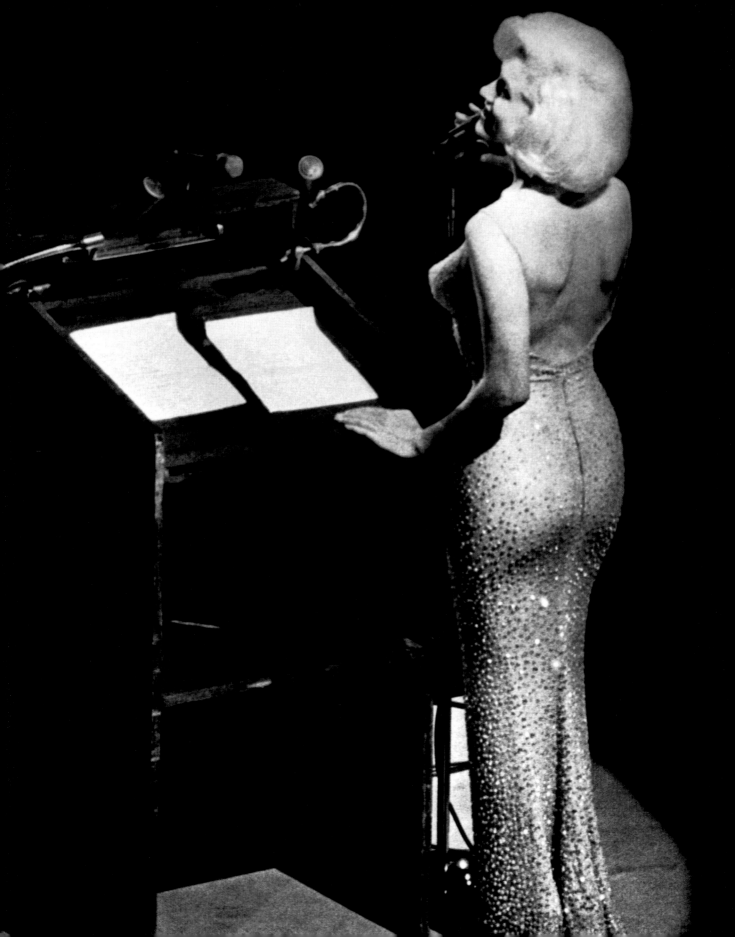

The Kennedy Brothers

One of the most famous, beautiful and free-spirited women in the world was, in the early 1960s, Marilyn Monroe. One of the most famous, powerful, handsome and, umm, free-spirited men in the world was, in this period, John F. Kennedy. Uh-oh. We should, as things speed up and head for their sad denouement, slow down just a little: This stage of Monroe's life, as chronicled in dozens of biographies, each with its own point of view, becomes as hazy as it must have seemed to her while she lived it. What really happened between the last weeks of 1961 and August 4, 1962, depends entirely on which version a reader chooses to believe. Much of the murk involves the Kennedys and the extent of Monroe's relationship with them. According to some retellings, in October 1961, Monroe met Attorney General Robert F. Kennedy and the following month his brother President John F. Kennedy at separate parties hosted by their sister Pat and her husband, actor Peter Lawford, seen with his Rat Pack leader, Sinatra, on the pages just previous. These would not be her last encounters with either brother, and it is a consensus view among her biographers that there was an affair between the actress and the President. She may have slept with Bobby as well. Unfortunately for the Kennedy family, there was one very public night, with flash-bulbs bursting, to stunningly record the one and also the other possible relationship. On the opposite page, Marilyn sings, in a dress that it was said she was sewn into, a singular version of "Happy Birthday." The circumstances will be explained on the pages immediately to come.

"WHEN HE BECAME PRESIDENT, [MONROE] BECAME VERY excited," her longtime friend Henry Rosenfeld said. "This was the most important person in the world and she was seeing him." She called him "Prez" and acted, Rosenfeld said, like a teenager. But Monroe failed to understand that she was only one of many women, all of whom were eventually disposable. (There were so many women that Kennedy reportedly could not remember their names. He called each of them "kid"—as in "Hello, kid"—to avoid embarrassment.) One of JFK's aides said, "This administration is going to do for sex what the last one did for golf." He was bragging, by the way.

In Monroe's mind, sadly, her relationship with Kennedy was more than an affair. Some have suggested that she believed the President would divorce Jackie and make her First Lady, unlikely as it sounds. But as we have seen, she had a pattern of investing men with impossible expectations, only to become resentful when they failed her. There are a dozen and more questions about what happened if you choose to build the list: Did she make too many demands? Did JFK tire of her? Did he become leery of the risk? Did Bobby force the question, or was it, finally, an executive decision?

J. Edgar Hoover was the first director of the Federal Bureau of Investigation, a role he had retained since the 1920s. The Kennedys hated the shrewd old man and would have kicked him to the curb if Hoover hadn't been willing and able to use the FBI as his own private police force, wielding and retaining power by amassing fodder for potential blackmail. The Kennedys, like Dr. Martin Luther King Jr., were in his crosshairs. A number of FBI documents later released through the Freedom of Information Act document JFK's indiscretions—including photos showing him and other men with naked women aboard a yacht; sex parties at the Carlyle Hotel in New York; and various other "immoral activities," such as fraternizing with mobsters at roisterous Palm Beach parties hosted by Sinatra.

In March 1962, Hoover reportedly told the President just how much he knew about the President's relationship with Monroe. More to the point, he told him that Monroe herself was associating with a man named Frederick Vanderbilt Field, a known communist. She was also seeing the handsome José Bolaños, a Mexican screenwriter with ties to both the left and the CIA's E. Howard Hunt. Hunt had spearheaded the Bay of Pigs invasion (and would later engineer the Watergate burglary). It was clear that Monroe was a security risk, a possible "subversive" with information about Cuba at a time when tensions with that country were rising. (Only a few months after Monroe's death, the world would be poised on the brink of nuclear war during the Cuban Missile Crisis.) But the Blonde and the Prez kept seeing each other. In fact, they were staying together at Bing Crosby's ranch that March of '62

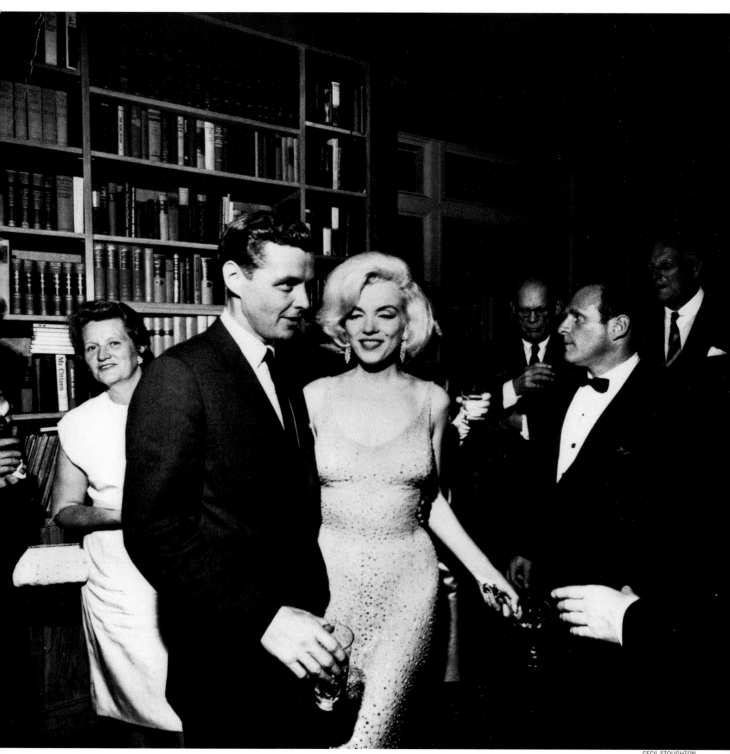

CECIL STOUGHTON

*W*hether Monroe's relationship with JFK went beyond a single night [one friend asserts that Monroe herself acknowledged a sexual liaison with Jack during the stay at Bing Crosby's house in March 1962] and whether there was also an affair with Bobby Kennedy is still debated—as is the theory that the Kennedys had something to do with her death. What is known are the events at JFK's 45th birthday celebration in New York, when the press—photographers and ink-stained wretches both—were on hand to document each and every glittering moment. In a life filled with notoriety, the evening of May 19, 1962, was perhaps the most notorious of all for Marilyn (excluding, of course, the night of her death). At Madison Square Garden, she purred a lascivious rendition of "Happy Birthday" to the President that, all these years later on recordings, remains shocking in its impropriety. (The President afterward told the crowd, "I can now retire from politics after having had 'Happy Birthday' sung to me in such a sweet, wholesome way.") Later over drinks, Marilyn met with Bobby and Jack and others at the Manhattan town house of United Artists president Arthur Krim (opposite, she is with JFK's brother-in-law Stephen Smith, and above, she is escorted at the Garden by—holy mackerel!—her former father-in-law Isidore Miller, playwright Arthur's dad).

when Monroe called her masseur, Ralph Roberts. "I've been arguing with a friend," Roberts claimed she said, "and he thinks I'm wrong about those muscles we discussed. I'm going to put him on the phone, and you can tell him." Seconds later, Roberts recognized Kennedy's distinctive Boston accent. How much advice he offered is unimportant.

JFK seemed to treat his relationship with Monroe like some kind of in-joke. He even flaunted it. On May 17, Monroe—then enraging Fox executives and director George Cukor with her constant absence from the set of her last, unfinished film, *Something's Got to Give*—flew to New York for her boozy, breathless rendition of "Happy Birthday" at the President's Madison Square Garden party. This was the height of hubris all around. Afterward, Monroe mingled with both Kennedy brothers at United Artists president Arthur Krim's town house. Many photos were allegedly taken of the threesome that night, but only one survives. In it (please see page 106), the Kennedys are determinedly turning their backs to the camera, but JFK's special assistant Arthur Schlesinger Jr. had noticed Bobby hovering around Monroe throughout the night. "Bobby and I engaged in mock competition for her," he said. "She was most agreeable to him and pleasant to me—but then she receded into her own glittering mist." The birthday party may have been the last time Monroe saw the President. But Bobby was another, newer story.

Bobby Kennedy had a lifelong interest in the underdog, a fact reflected in his determined work for civil equality. Noble as these efforts were, they may have been a form of projection: Born into great wealth and privilege, he nevertheless lacked status in the Kennedy family's all-important male hierarchy. He was his mother's pet, but his father called him the "runt." Perhaps in compensation, Bobby later became relentless, aggressive and ruthless politically—particularly when it came to his brother.

"RFK had always protected his brother's secrets," his biographer Evan Thomas wrote, "from the time he hid JFK's crutches in the car during the 1952 Massachusetts Senate campaign. In the summer of 1962, he had to contend with his brother's twin addictions—his promiscuity and his dependence on painkillers." In late May, Thomas reports, "the White House heard that the troubled actress was spreading stories around Hollywood of her purported affair with the President."

Bobby's sympathy for the downtrodden may have merged with his fixer impulses when faced with the troublesome—and clearly lost—Monroe. The exact nature of their interaction will perhaps never be known, but Thomas suggests that Bobby met Marilyn at a party thrown in his honor by—you perhaps guessed it—Peter Lawford, in October 1961. Bobby saw Marilyn again at the Lawford house in February 1962. For the latter occasion, she prepared herself by asking her shrink Greenson's son, Danny, a series of banal questions: "What is it like to be attorney general?" was one.

Bobby saw Monroe again at Lawford's house and even went to see her newly purchased house in Brentwood. Did he, too, succumb to Monroe's charms? It's possible. In a distinctly Catholic way, he was "repulsed and fascinated by sin," Thomas wrote. Bobby's secretary at the time, Angie Novello, claimed that he simply wanted to help her—perhaps he even succeeded in reinstating her contract with Fox, which had dumped her during the disastrous filming of *Something's Got to Give*. We know that Monroe began phoning the attorney general. There were eight calls in June and July. (Her telephone records went mysteriously missing after her death but were later recovered.) And Bobby's sister Jean Kennedy Smith wrote on an undated thank-you note: "Dear Marilyn . . . understand that you and Bobby are the new item! We all think he should bring you with him when he comes back east."

But Bobby, too, would soon pull away.

On the weekend of July 28 and 29, Sinatra invited Monroe to Cal-Neva Lodge, the resort he co-owned with mobster Sam Giancana. (It had also been a favorite haunt of Joseph P. Kennedy, Jack and Bobby's father.) The name

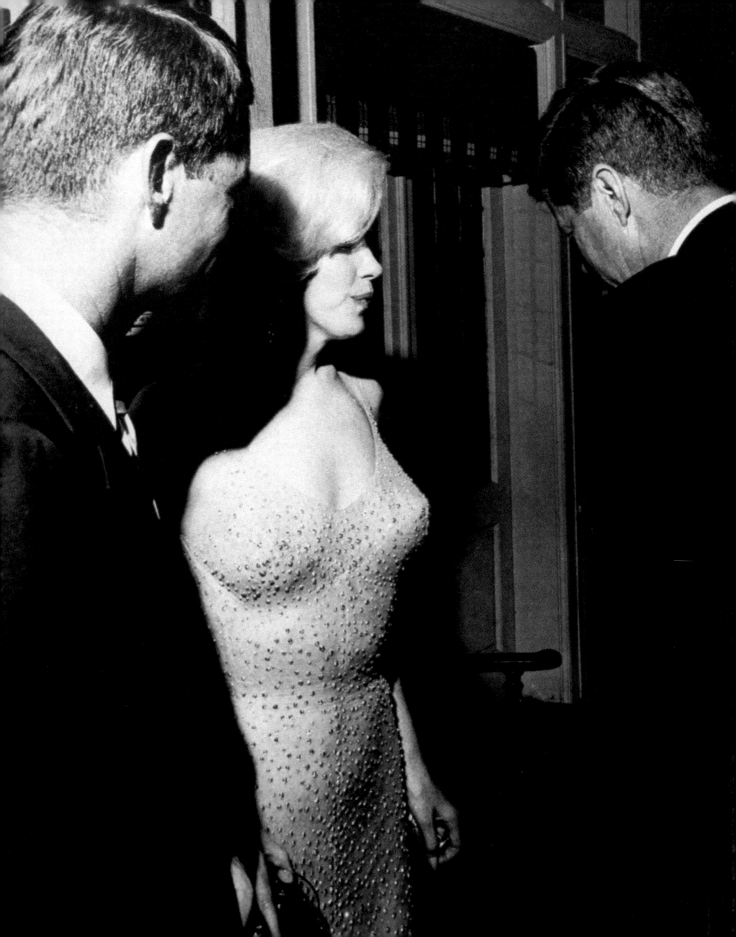

The Kennedy Brothers

The Kennedy brothers, Bobby (left) and Jack, with Marilyn on that May night in '62. Less than three months later, she would be dead in Brentwood, California, and this famous family from Massachusetts would be drawn in. It is known that before eight p.m. on August 4, she took a phone call from her former stepson, Joe DiMaggio Jr. Shortly after, some accounts say, she was on the phone again, this time with Jack and Bobby's brother-in-law Peter Lawford, who that night was having a small gathering to which she had been invited. During their call, Lawford told police much later (his story undergoing revisions through the years), Monroe refused to join him. He said she was speaking in a slurred voice that became less and less audible. He yelled into the phone, trying to startle her, to no avail. "Say goodbye to Pat," she said, according to Lawford. "Say goodbye to Jack. And say goodbye to yourself because you're a nice guy." That was Lawford's story, and it did absolutely nothing to stop the questions regarding his role and that of the Kennedy brothers. Why was there a lag of several hours between the discovery of Monroe's body and when the police were called? Why did the coroner receive results for only some of the lab tests? Was Bobby Kennedy in Los Angeles, as some have said, and did he visit Monroe? Might this have been a politically motivated murder done either by or on behalf of the Kennedys—to protect reputations or state secrets? Alternatively, was Monroe killed by an enemy of the Kennedys? Or was it, after all, just an accident? Perhaps so, perhaps so, thought historian Arthur Schlesinger Jr., who was standing just behind Jack when this photograph was taken at Krim's town house, and who later wrote in his journal about the fragility of the woman he had met that night: "I must confess that the report yesterday of Marilyn Monroe's death quite shocked and saddened me (but did not surprise me). I will never forget meeting her at the . . . party following the JFK birthday rally . . . The image of this exquisite, beguiling and desperate girl will always stay with me. I do not think I have seen anyone so beautiful; I was enchanted by her manner and her wit, at once so masked, so ingenuous and so penetrating. But one felt a terrible unreality about her—as if talking to someone underwater."

Cal-Neva came from the gimmicky fact that the resort straddled the state line, located half in Nevada and half in California. Gambling was legal in the former; it was not in the latter. So a dividing line in the resort marked the spot where Nevada—and gambling—began.

Monroe was seen drunk and disoriented getting off the plane back to Los Angeles that Sunday, but no one knows for certain what had transpired at the lodge. One theory was offered by the photographer Billy Woodfield, who knew Sinatra, having worked for him in the past. Woodfield said that Sinatra came to him with film that he wanted developed. When Woodfield did, he saw images of Monroe naked and being abused with Giancana present at the Cal-Neva Lodge. He told Sinatra to burn the film.

What was this all about? Donald H. Wolfe has speculated that Sinatra invited Monroe to the lodge to get her out of Los Angeles while Bobby was there. To secure the actress's silence, the photos were protective blackmail. The overarching message: Stay away from the Kennedys.

Monroe now had less than one week to live. She had come such a long and strange—often tortured—way from the unwanted child alone in the movie theater. Along with her immense success and great achievements, she had endured miscarriages, an untold number of abortions, three or four failed marriages and many other broken relationships. Did a Kennedy betrayal kick her over the edge into accidental overdose or suicide? Or did something more sinister happen? A palpable sense of resignation—more philosophical than despairing—suffuses her poignant last interview with LIFE's Richard Meryman: "It might be kind of a relief to be finished," she said. "It's sort of like, I don't know what kind of yard dash you're running but then you're at the finish line, and you sort of sigh—you've made it! But you never have—you have to start all over again."

Two days after this interview was published, Monroe was allegedly found by Eunice Murray, her mousy, somewhat mysterious housekeeper, in her locked bedroom at around three-thirty in the morning. The unsettling questions surrounding Monroe's death are unlikely to ever be solved to everyone's satisfaction. But in 1985, while being interviewed by Anthony Summers for a BBC documentary, Murray offered up a clue. After the cameras had stopped rolling—but the sound was still on—she said, "Why, at my age, do I still have to cover up this thing?" She went on to say that Bobby Kennedy visited Monroe on the day of her death and that an ambulance had come to the house while Monroe was still alive. "Over a period of time, I was not at all surprised that the Kennedys were a very important part of Marilyn's life," Murray said. "I was a witness to what was happening . . . It became so sticky that the protectors of Robert Kennedy, you know, had to step in and protect him."

A number of people, including Robert Slatzer (who claimed much), claim to have seen a red diary in which Monroe had written top-secret information—perhaps gleaned from the Kennedys—about Cuba, about Hoover and about other matters of national security. Still other witnesses throughout the decades claim to have heard incriminating surveillance tapes. Private investigator Fred Otash said that he had bugged the star's house and had heard JFK and Monroe having sex. Another tape was allegedly recorded on the last night of Monroe's life. Those who claim to have heard this say that Monroe screamed and Bobby repeatedly said, "Where is it? Where the hell is it? I have to have it! My family will pay you for it!"

Yes, well.

Did her doctors, Hyman Engelberg and Ralph Greenson, and Eunice Murray wait four hours before calling the LAPD to allow Bobby Kennedy and Peter Lawford, or their associates, to eliminate evidence? As with so much else, we will probably never know. But perhaps we can take a lead from Ms. Murray who, when confronted with decades' worth of lies surrounding Monroe's last hours, said, "I told whatever I thought was . . . good to tell."

Marilyn's story, beginning to end.

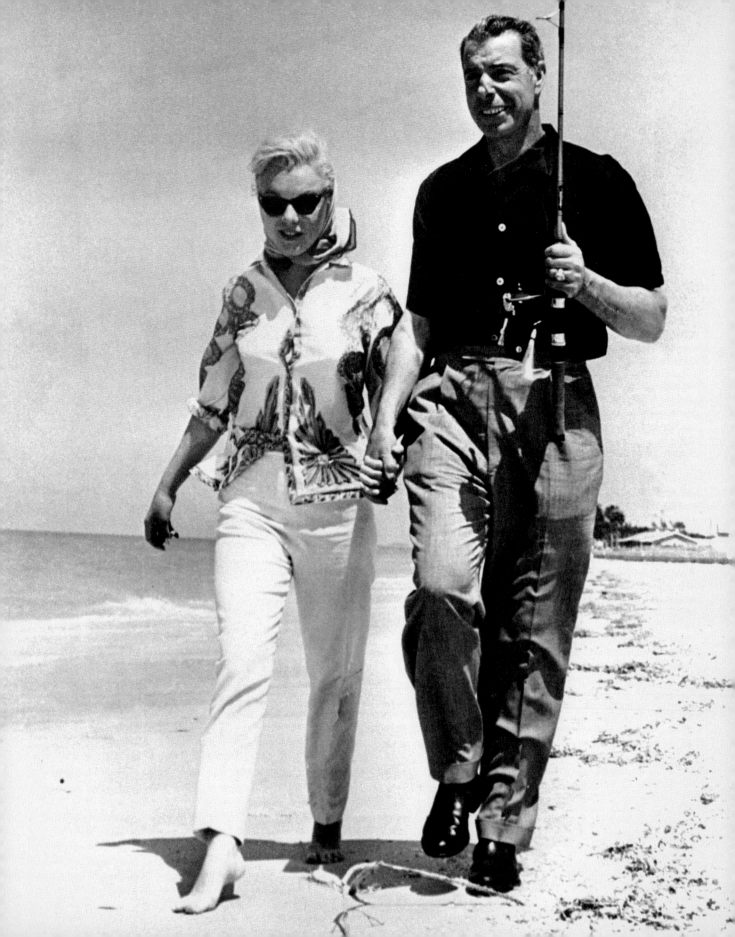

The Return of DiMaggio

*I*t was always said, and it always will be said: DiMaggio was there for her when no one else was. It will always be said because, in many ways, it is true. He was harsh to her in indefensible ways when they were husband and wife, but he never stopped loving her, and he never did not reach out to her. The photographs on these pages were taken in Belleair, Florida, in 1961, once he had reentered her life in a meaningful way. Earlier in the year, there had been concern that she was becoming suicidal, and her psychoanalyst had urged hospitalization. Monroe checked herself into the Payne Whitney Clinic in New York City. Once inside, she panicked. Was the madness that had consumed her mother being visited upon her? She slammed a chair into some glass, breaking off a piece. When personnel returned to her room, she threatened to cut herself with it if they didn't let her go. "If you are going to treat me like a nut, I'll act like a nut," she told them. She was taken by force to another room where, she later wrote, the walls bore "the violence and markings" of previous patients. She heard the screams of other women. "I'm locked up with these poor nutty people," she wrote to Lee and Paula Strasberg in a plea for help. "I'm sure to end up a nut if I stay in this nightmare." It was DiMaggio who intervened. Three or four days after Monroe had checked in [accounts differ], Marilyn reached Joe by phone in Florida. He rushed to New York and threatened to tear apart the hospital "brick by brick" if Monroe was not released the next day. She was, and DiMaggio would stay in the picture from here on out.

"THE CURTAIN FALLS," THE TV ANCHOR SAID INTO THE camera, standing before the wall that separated the Westwood Village mortuary grounds from the dense crowd that had come to watch Monroe's funeral on August 8, 1962. "We grasp at straws, as if knowing how she died—or why—might enable us to bring her back."

The New York Times reported that DiMaggio leaned over her casket, kissed her lifeless lips and said, "I love you, I love you." He also organized the funeral—with a vengeance. Many who were close to Monroe—including Sinatra and Lawford—were shocked to find that DiMaggio had excluded them from the services. When studio executives tried to persuade DiMaggio to let Hollywood in, he replied, "Tell them, if it wasn't for them, she'd still be here." Monroe's longtime makeup artist, Whitey Snyder, said, "He blamed Hollywood for her death—Hollywood and the Kennedys."

Less than a week after Monroe's demise, JFK, the Lawfords and Pat Newcomb, Marilyn's publicist, were photographed grinning on a Coast Guard yacht in Maine. The Kennedy brothers went blithely on with their lives—or what was left of them. JFK had little more than a year to live, his life cut short by an assassin's bullet in Dallas on November 22, 1963. Bobby would be felled by yet another bullet on June 5, 1968, in the kitchen of the Ambassador Hotel—the very place where, as we noted long ago, Monroe had begun her modeling career almost 20 years before.

The famous woman who had begun life as a naive girl named Norma Jeane was used and discarded by many lovers in her short time on earth—and she discarded many in return. But one man, though he was not always good to her, remained loyal to the end and beyond. For two decades, DiMaggio sent flowers to her grave twice a week. Said Monroe's longtime friend actor Brad Dexter, "He was still in love with her."

There is much more to be said about Marilyn Monroe. Thus ends, however, the loves of Marilyn.

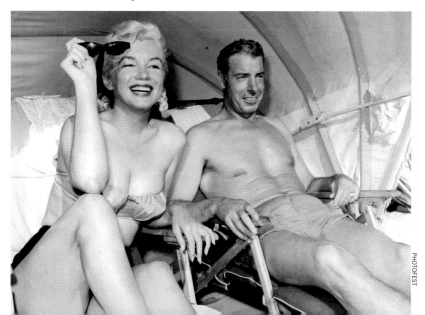

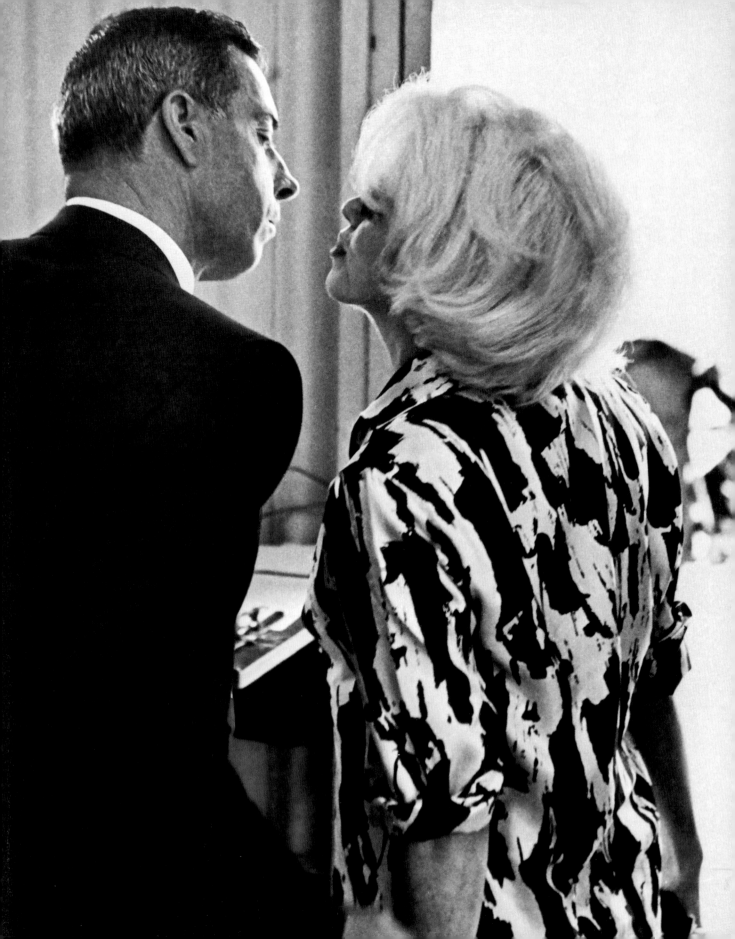

With a person as passionate—and with a person who stirred such grand passions—as Marilyn Monroe, everyone demands to know: Who was the love of her life? No one will ever come up with a more solid candidate than Joe DiMaggio. On the opposite page, on February 21, 1962, he bids bon voyage to his ex-wife as she leaves Miami for a vacation in Mexico. Below, he grieves on August 8, 1962, alongside his son, Joe Jr., at her funeral. What has happened: Monroe has signed to star in another film for Fox, Something's Got to Give, but in April 1962, when the time comes to shoot her first scene, she is too ill to report for work. She stays out for nearly three weeks, puts in a few days of work, then says she is jetting to New York to take part in that Democratic fund-raiser celebrating President Kennedy's 45th birthday. The studio, despite having earlier approved the trip, counters that if she leaves, she will be in breach of contract. She ignores her bosses and is introduced by Peter Lawford to 15,000 partygoers at Madison Square Garden, shimmering like a disco ball in a dress as snug as plastic wrap. Two weeks later, back in California, Monroe celebrates her own 36th birthday on the film set with a sparkler-studded cake. It will be her last day at work. When she doesn't show up the following week, she is fired. The studio subsequently files a $750,000 breach of contract lawsuit. Dean Martin, Monroe's costar in Something's Got to Give, says he will walk if Monroe isn't brought back. Fox capitulates, and by the beginning of August 1962, the studio signs Monroe to a second contract. While she is negotiating this new deal in July, Monroe meets with LIFE's Richard Meryman for a series of interviews that will constitute her last. At one point she compares fame to caviar—"not really for a daily diet, that's not what fulfills you"—and says that celebrity can be a very dangerous business. "You're always running into people's unconscious." She talks about being "picked on" and pulled apart. She vents her anger at the studio. She says further: "I don't think people will turn against me, at least not by themselves. I like people. The 'public' scares me, but people I trust."

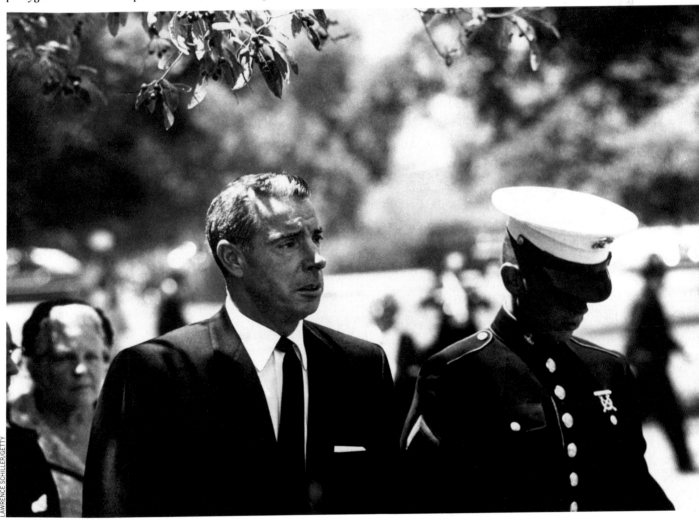

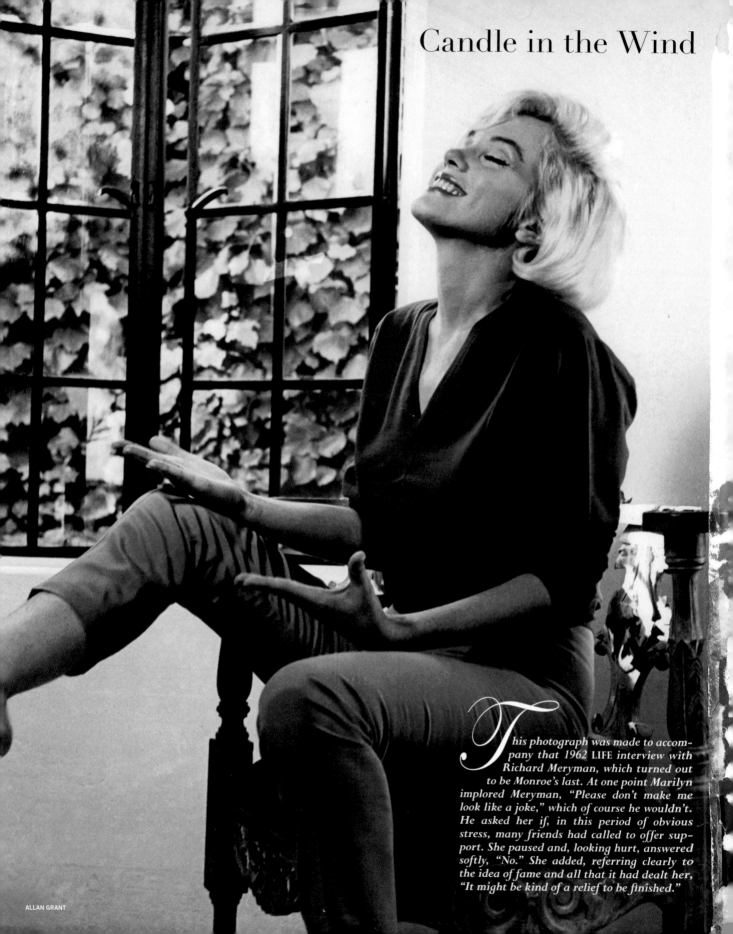

Candle in the Wind

This photograph was made to accompany that 1962 LIFE interview with Richard Meryman, which turned out to be Monroe's last. At one point Marilyn implored Meryman, "Please don't make me look like a joke," which of course he wouldn't. He asked her if, in this period of obvious stress, many friends had called to offer support. She paused and, looking hurt, answered softly, "No." She added, referring clearly to the idea of fame and all that it had dealt her, "It might be kind of a relief to be finished."

DATE DUE

FOLLETT